LOVECRAFT
MONSTERS

chartwell books

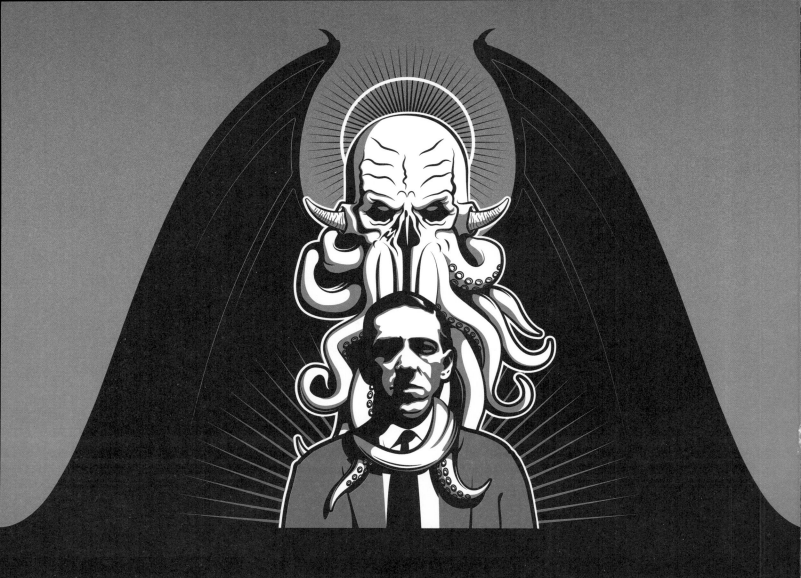

Discover the terrifying world created by H.P. Lovecraft and explore your creative side. Horror fans and those fascinated by his eerie tales will enjoy this coloring book.

H.P. Lovecraft was an American writer born in 1890. His most popular works include "The Call of Cthulhu," *At the Mountains of Madness*, and *The Shadow over Innsmouth*. He was first published in the late 1800s in inexpensive magazines called pulp magazines. During that time, he became a part of the community of authors now known as the "Lovecraft circle." Lovecraft often struggled financially and was virtually unknown during his lifetime. He is now one of the most well-known horror fiction writers and millions of copies of his work have been sold. Lovecraft's stories have inspired movies and television shows including the HBO series *Lovecraft Country*.

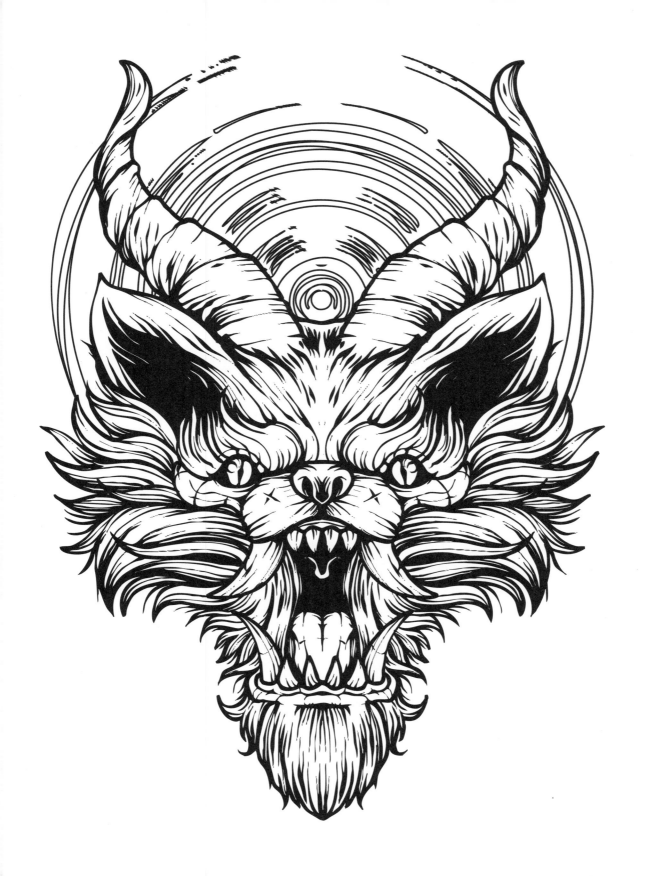

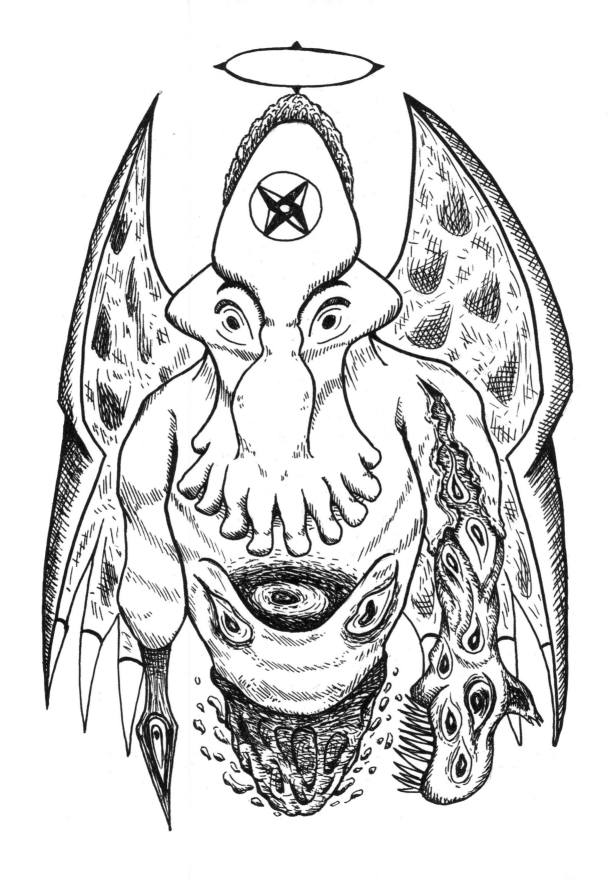

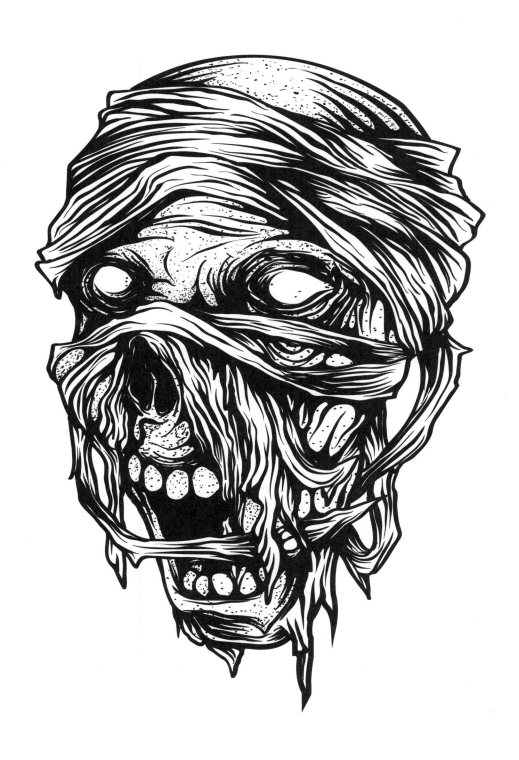

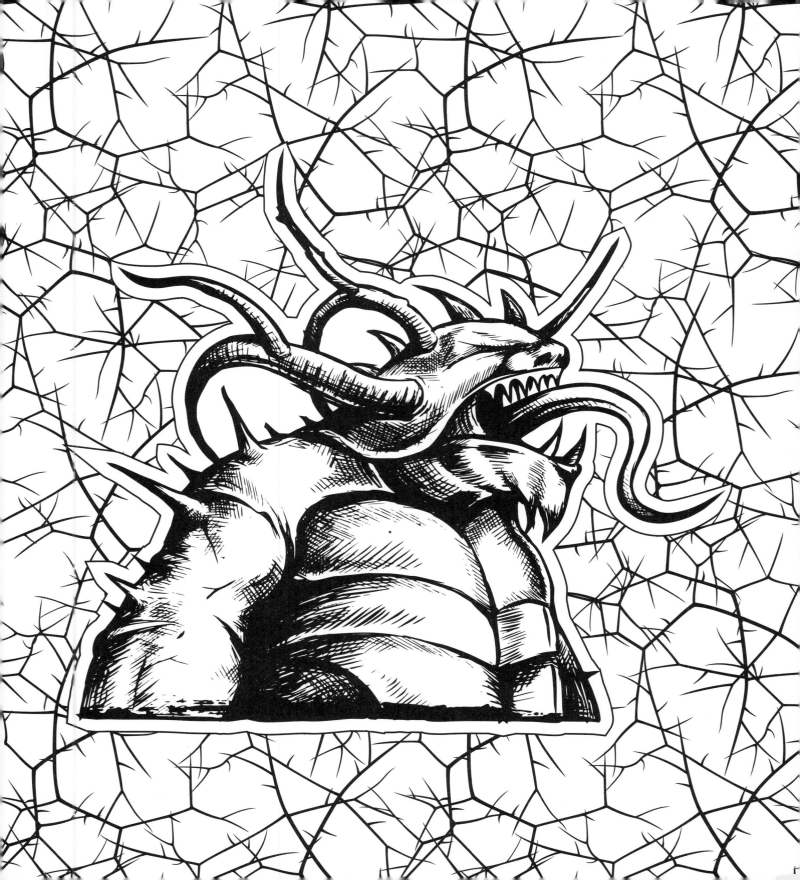

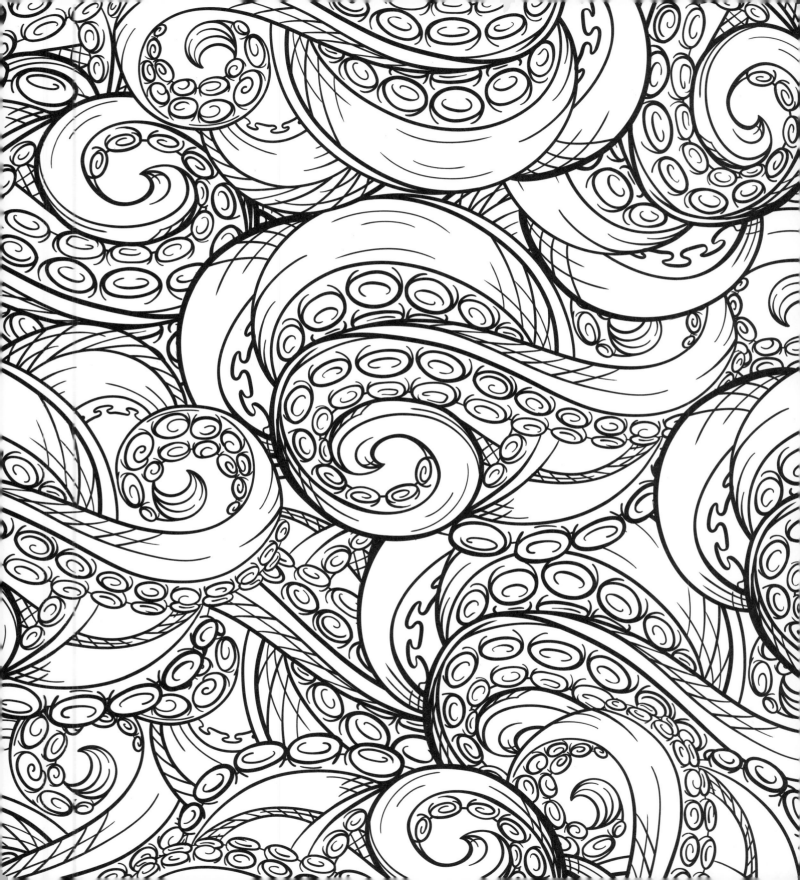

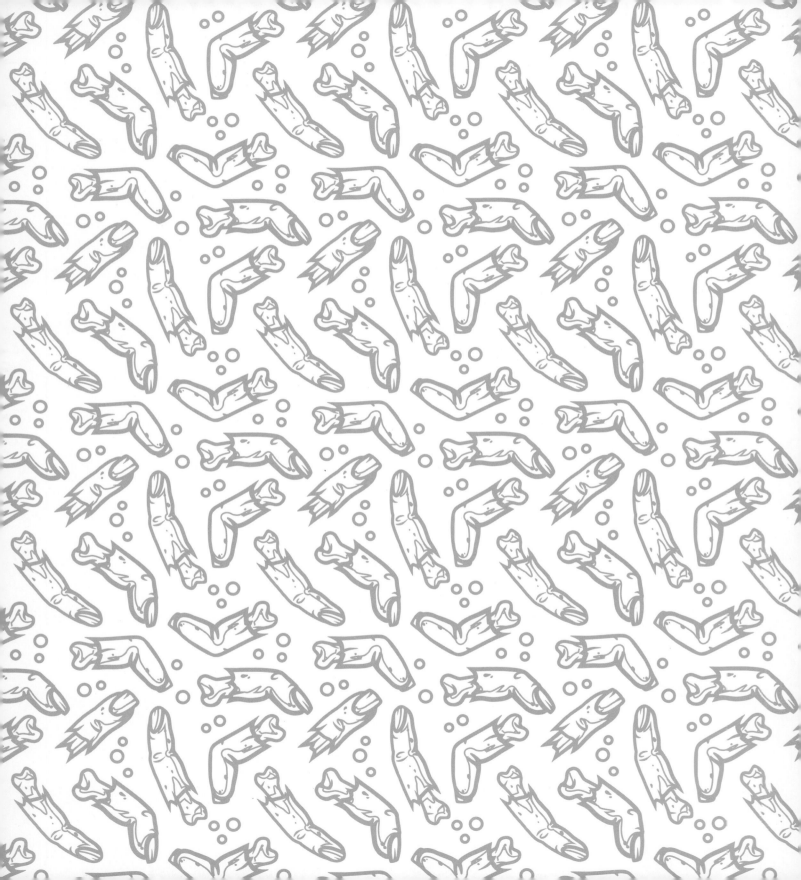

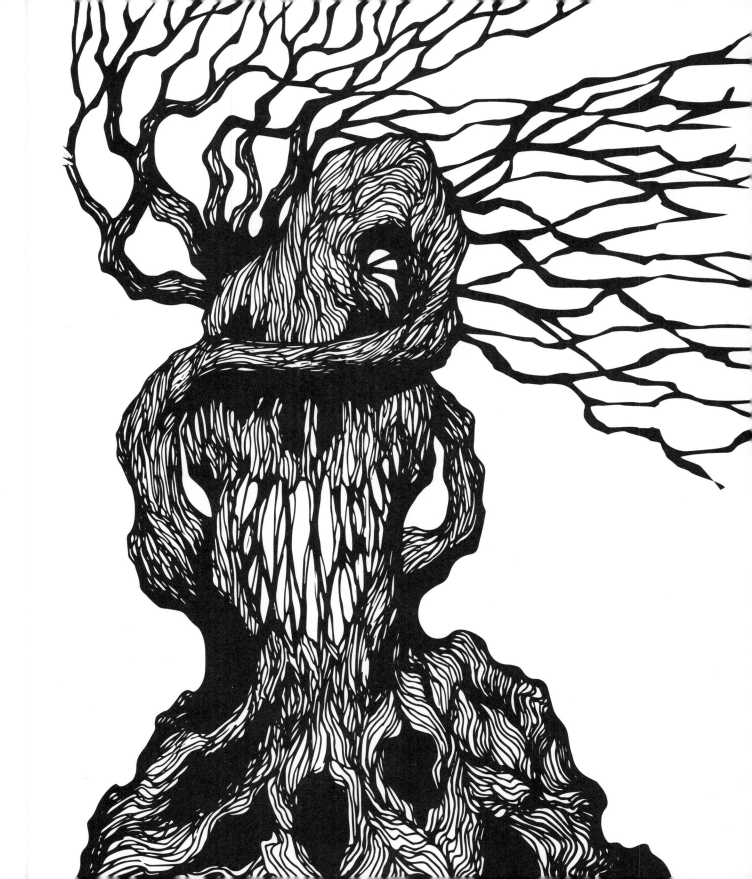

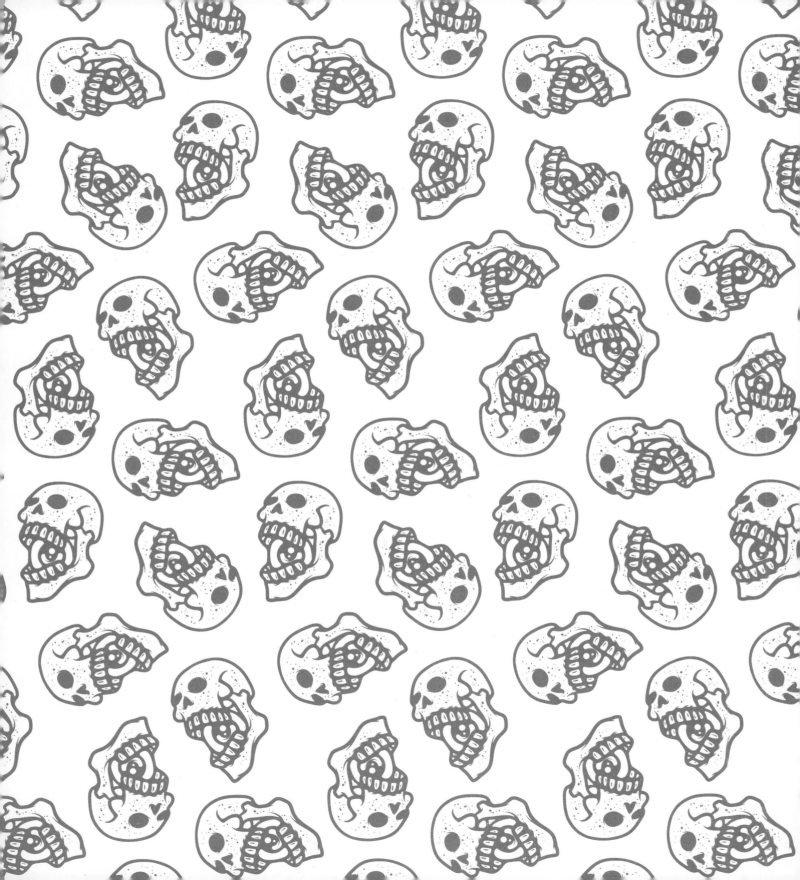

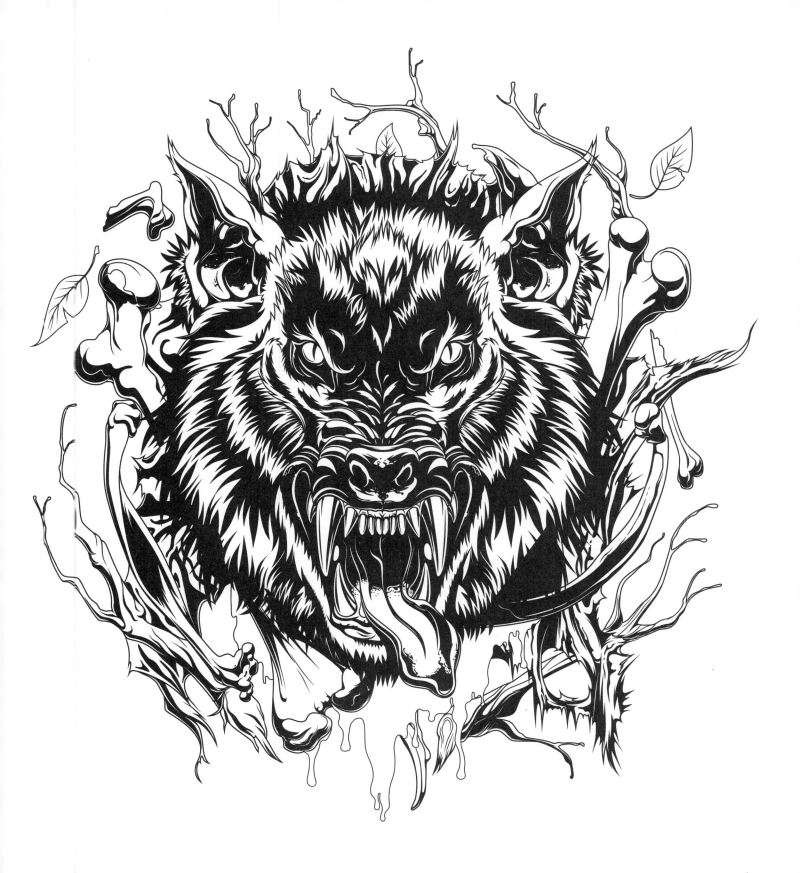

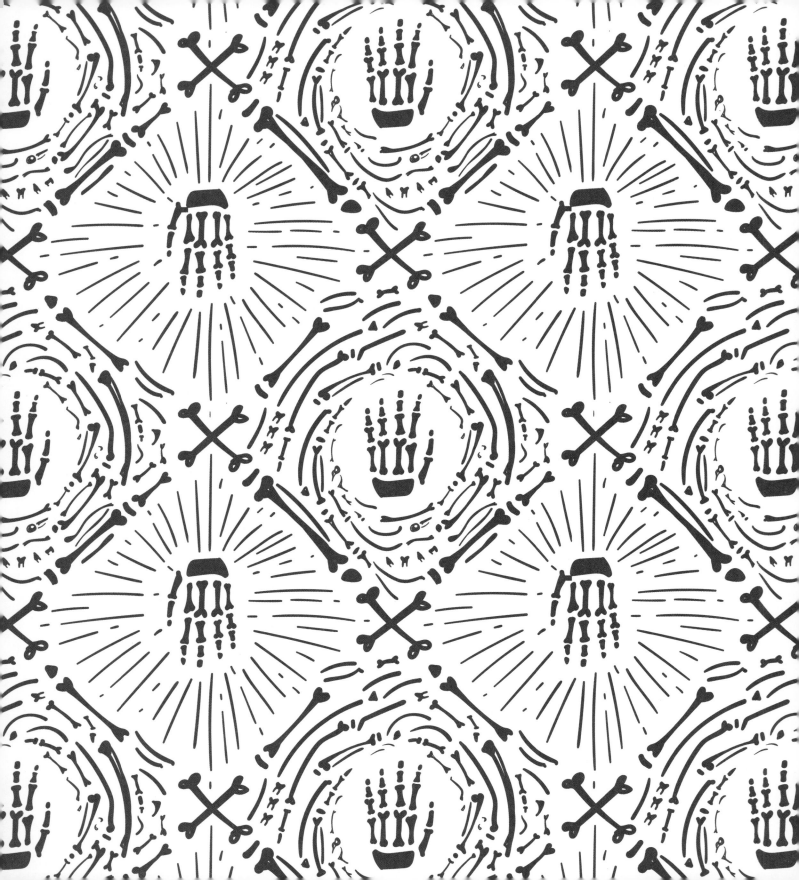

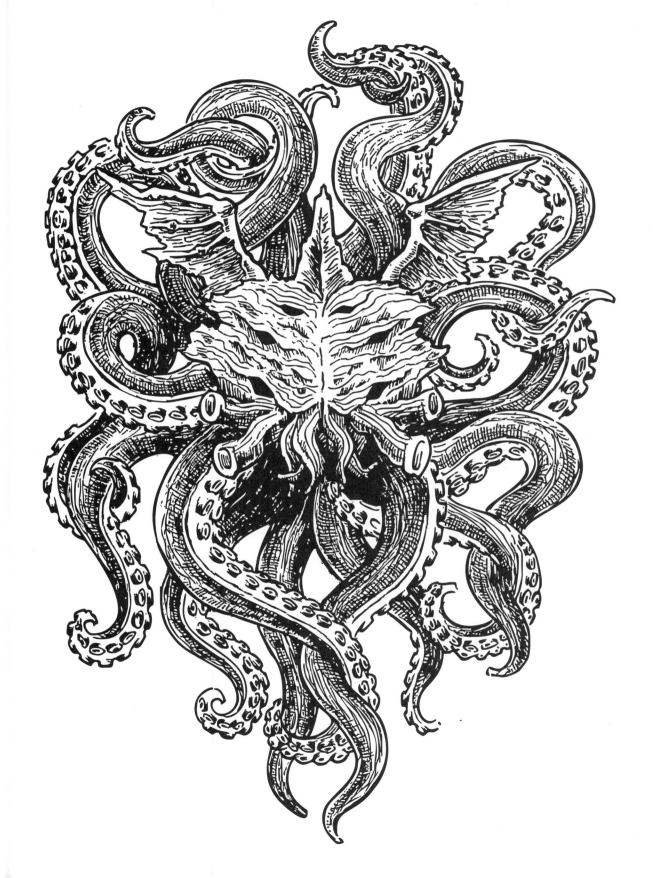

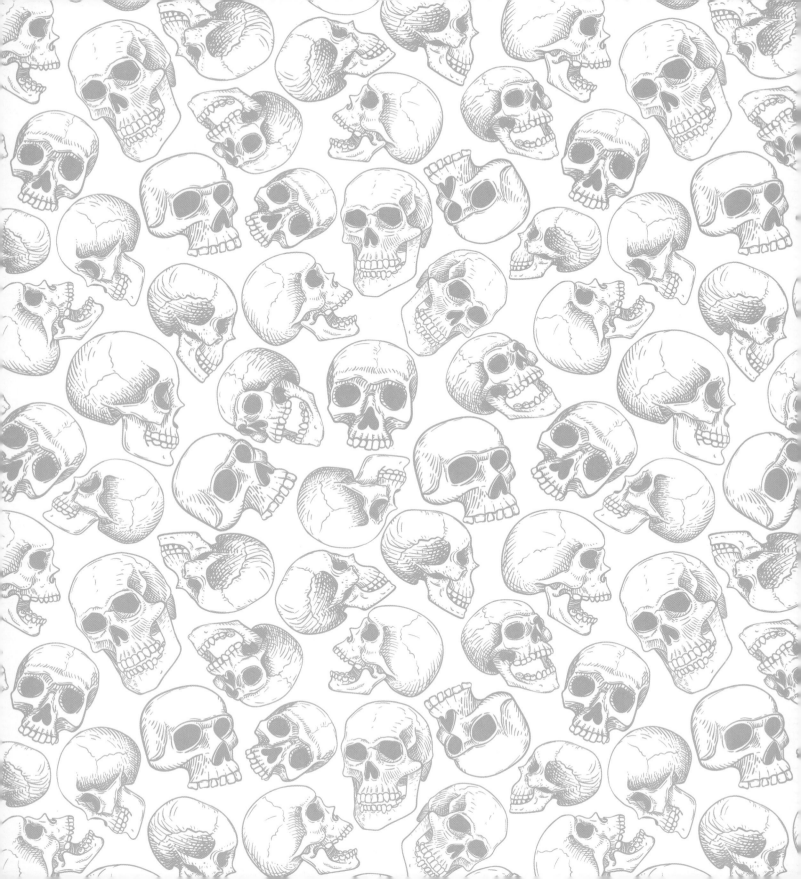

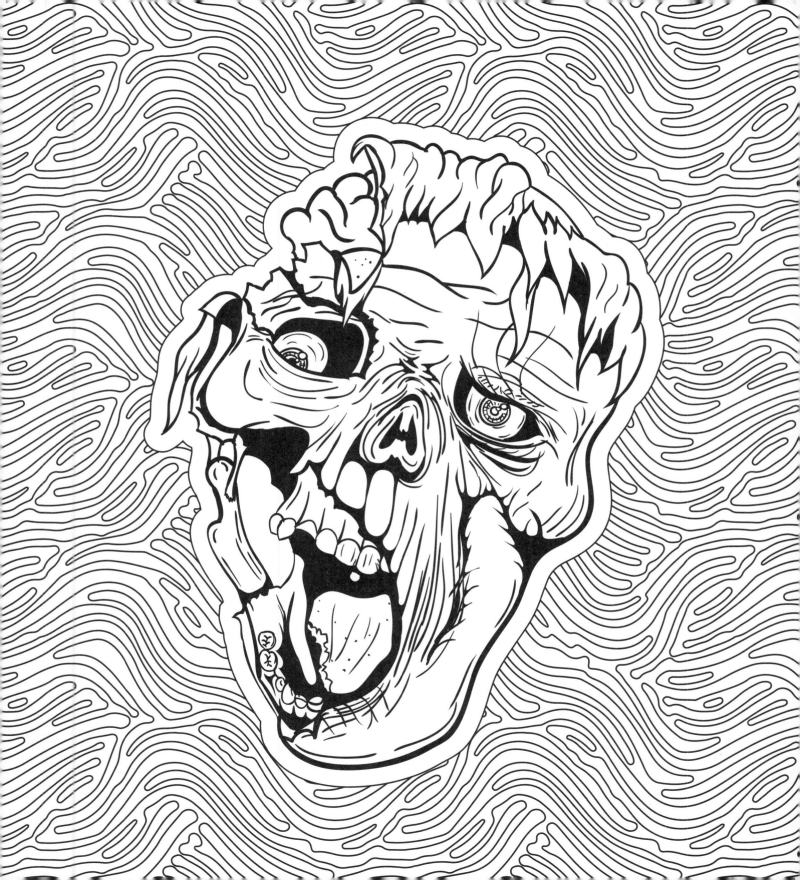

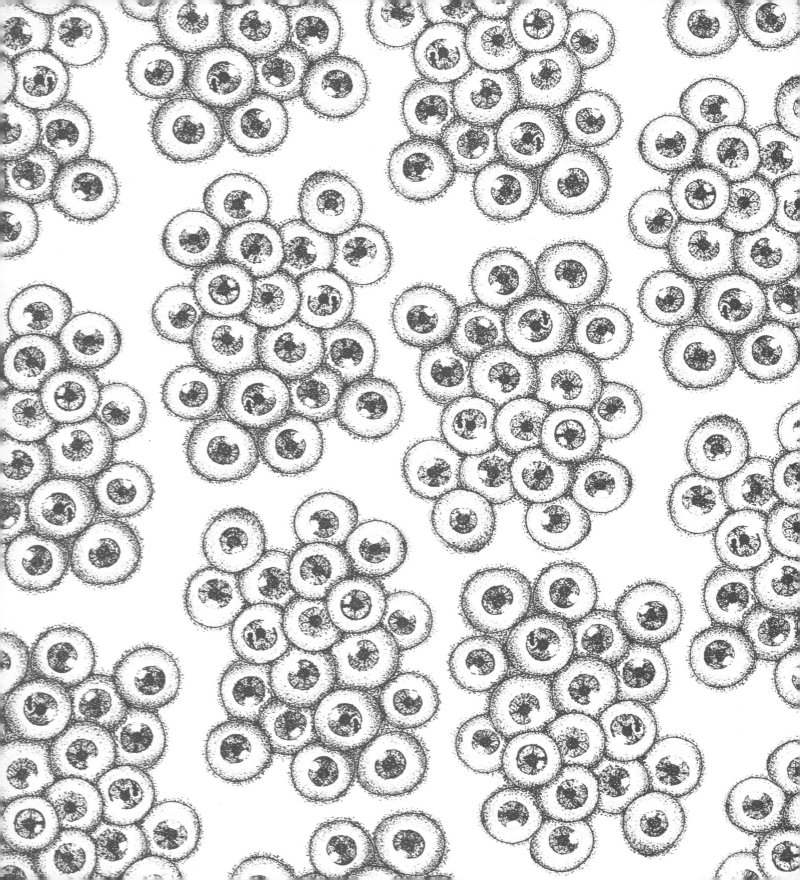

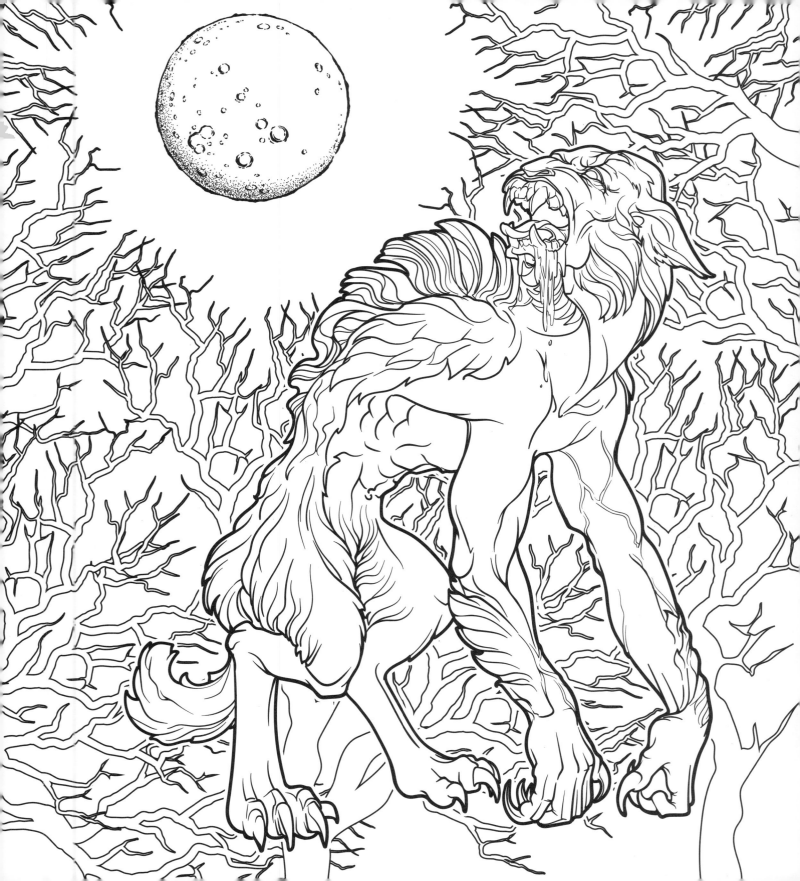

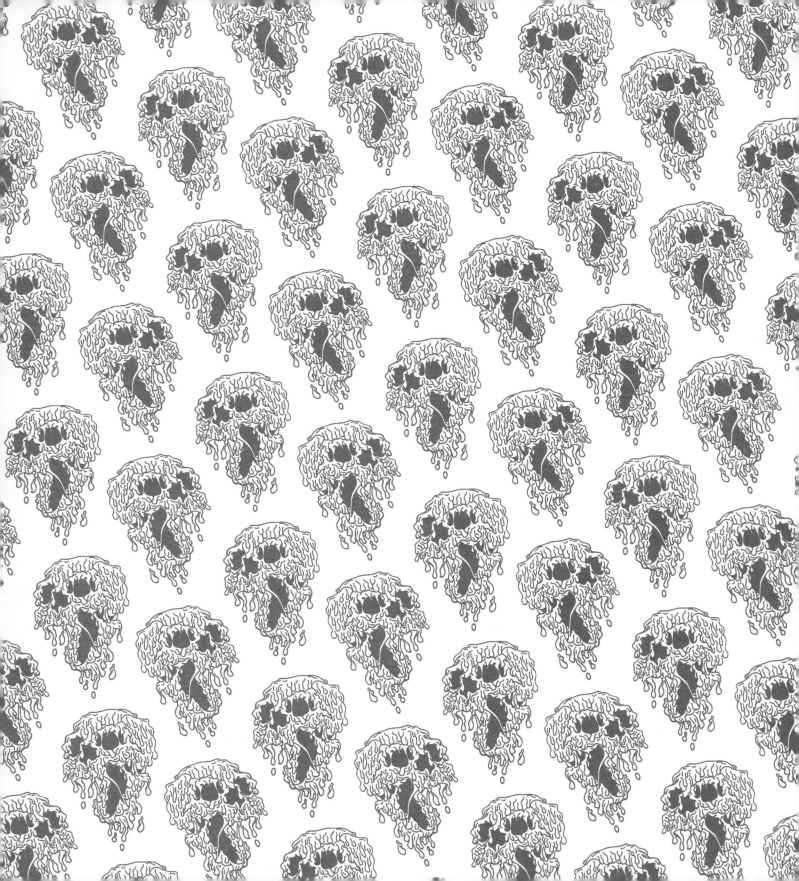

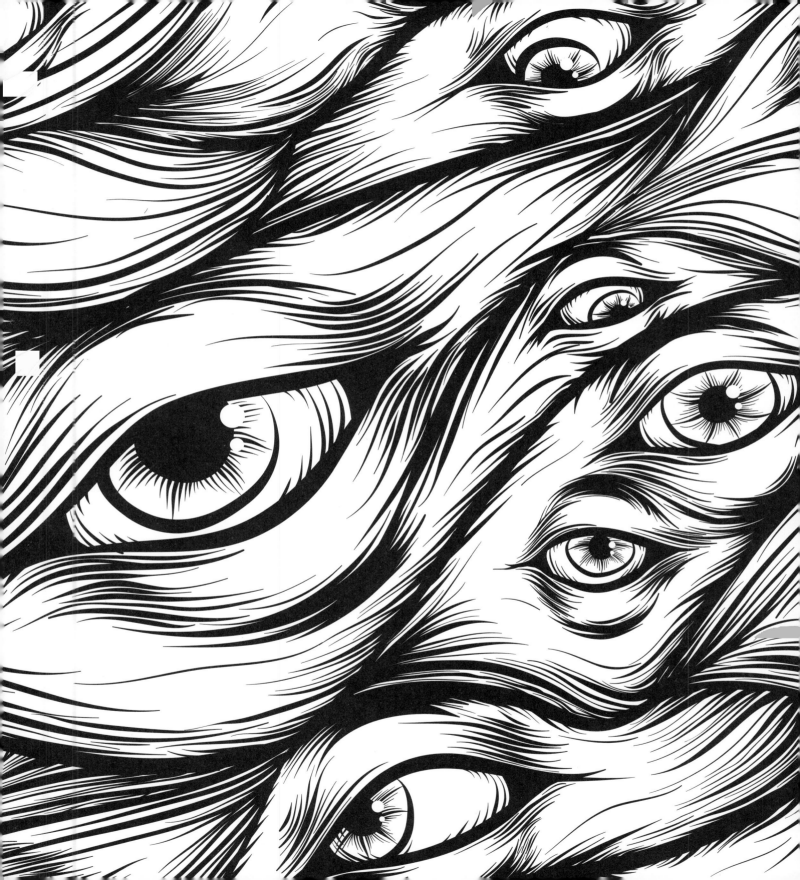

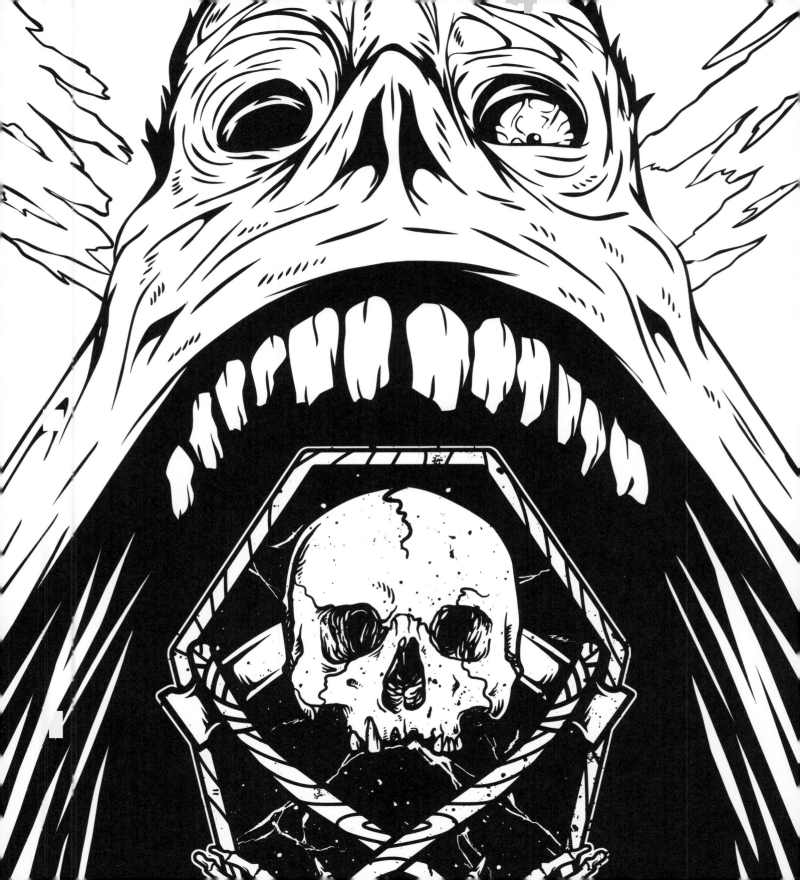

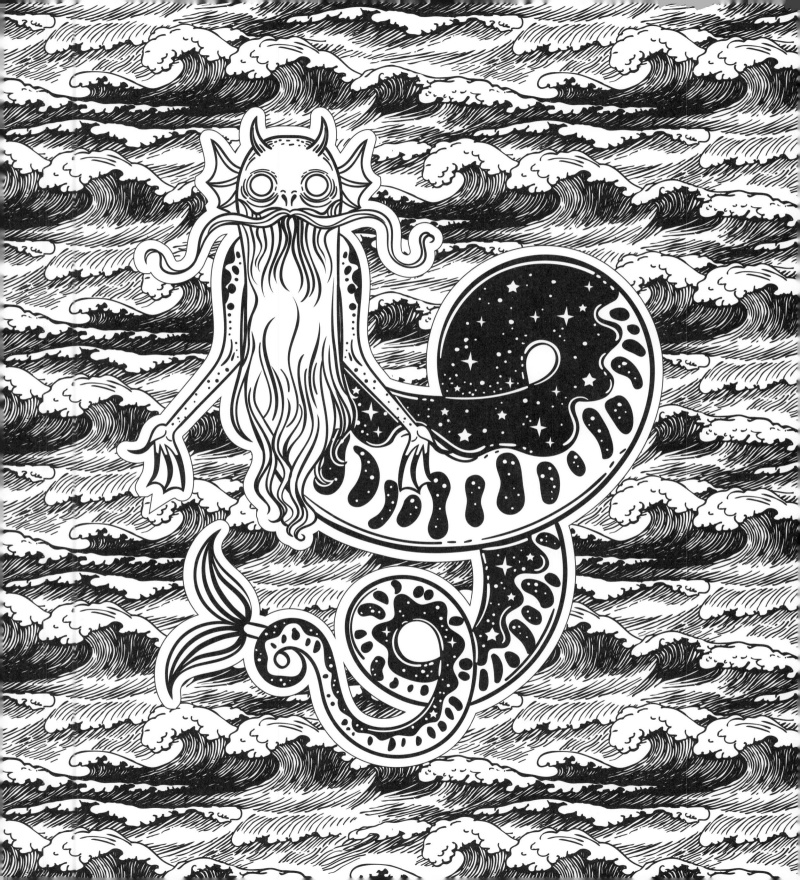

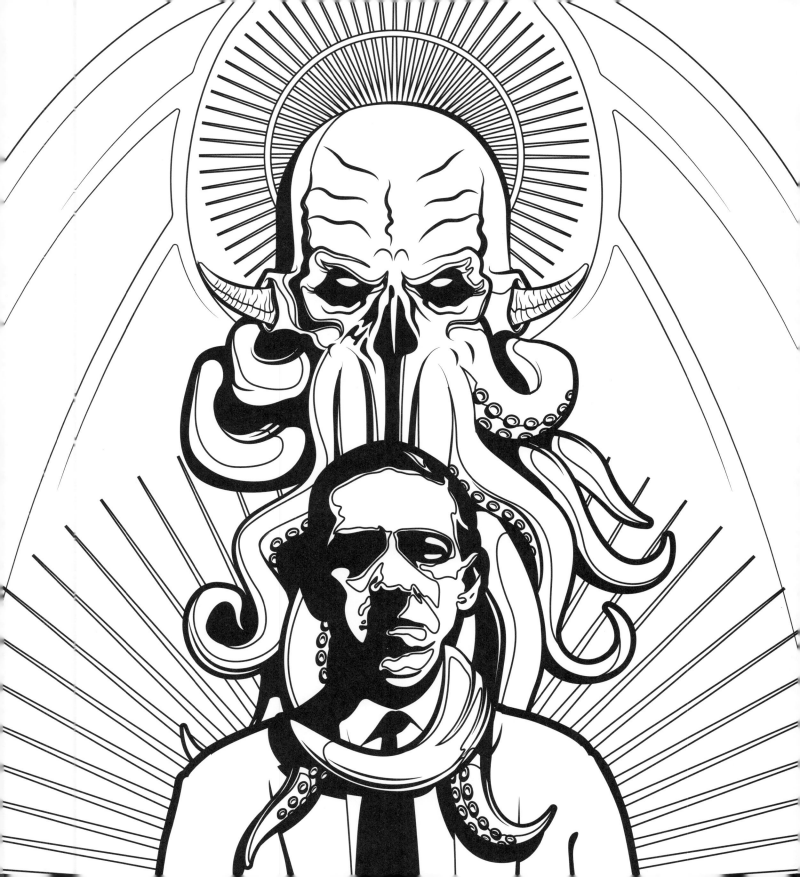

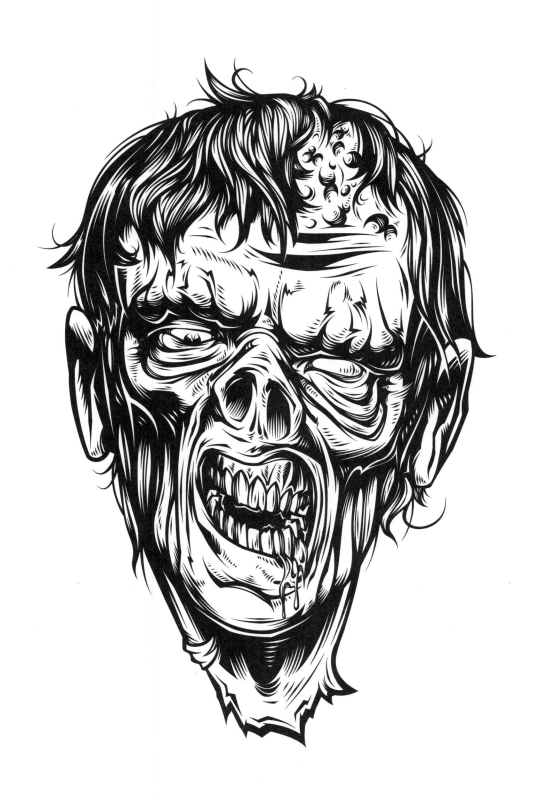

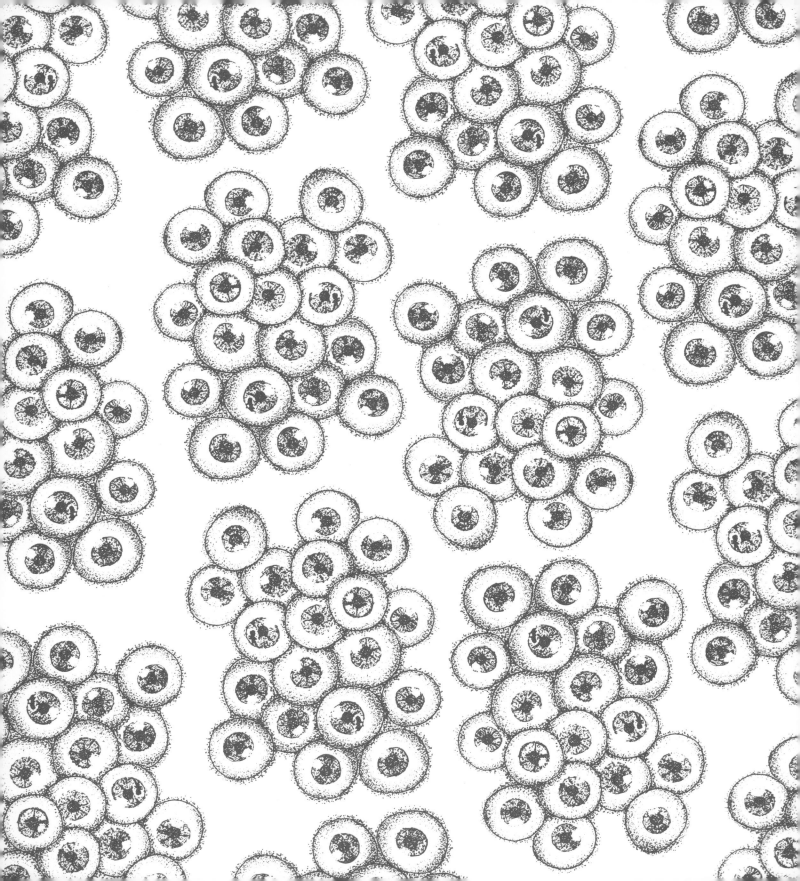

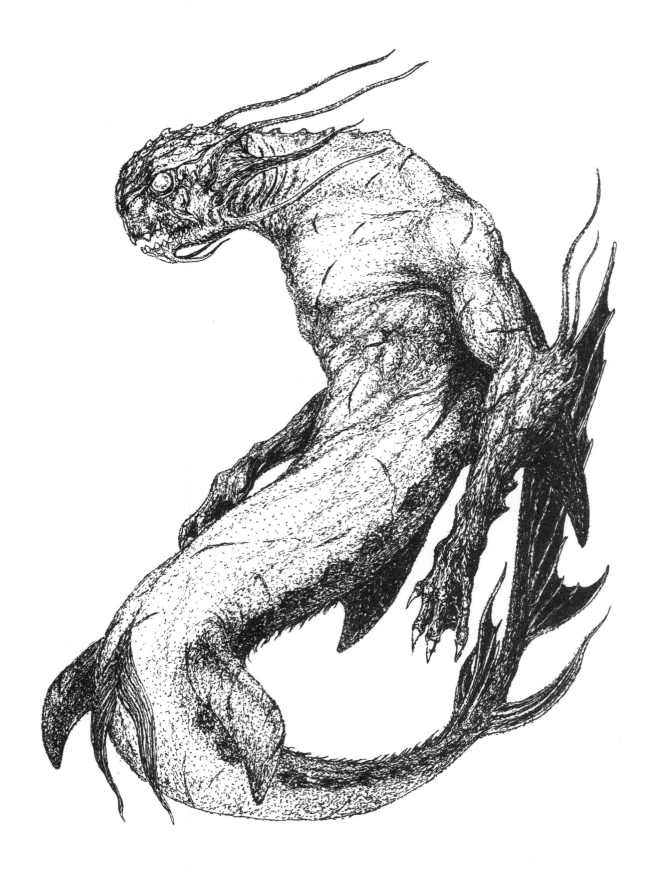

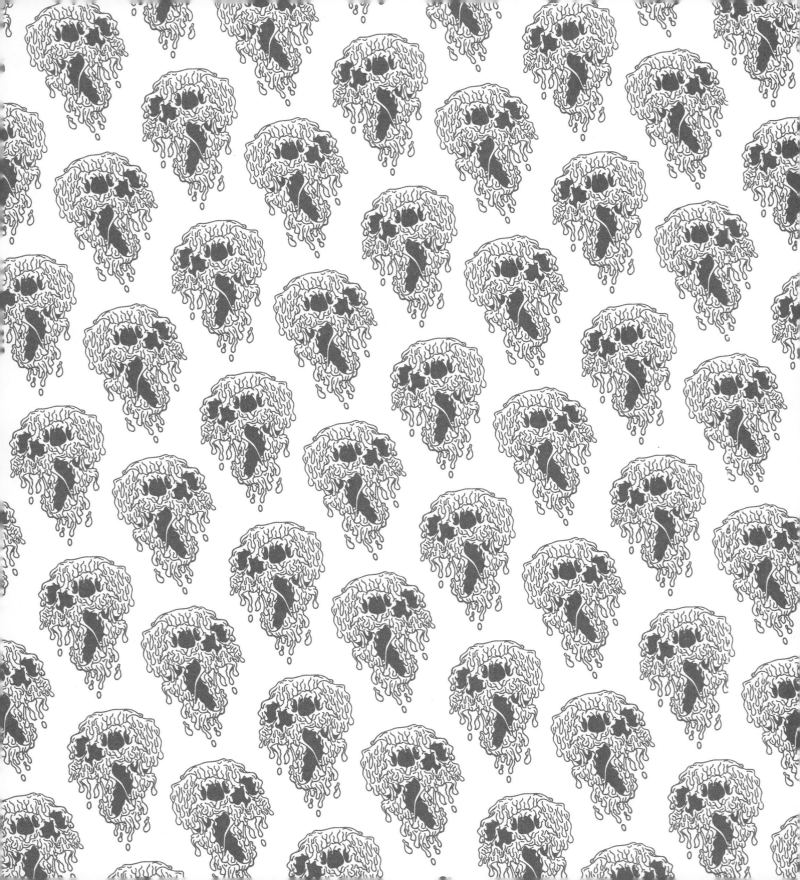

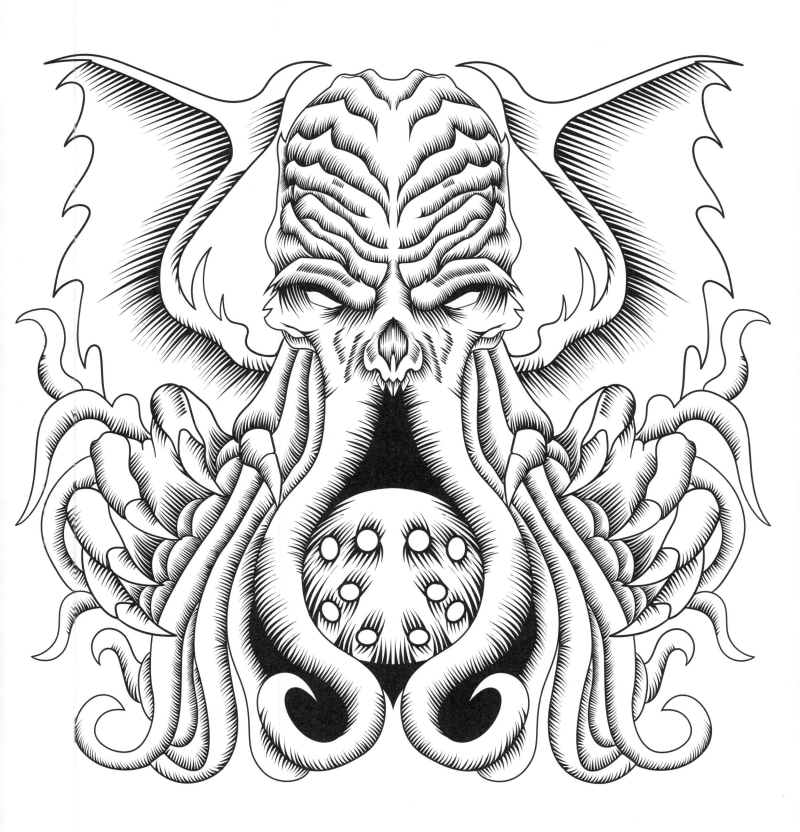

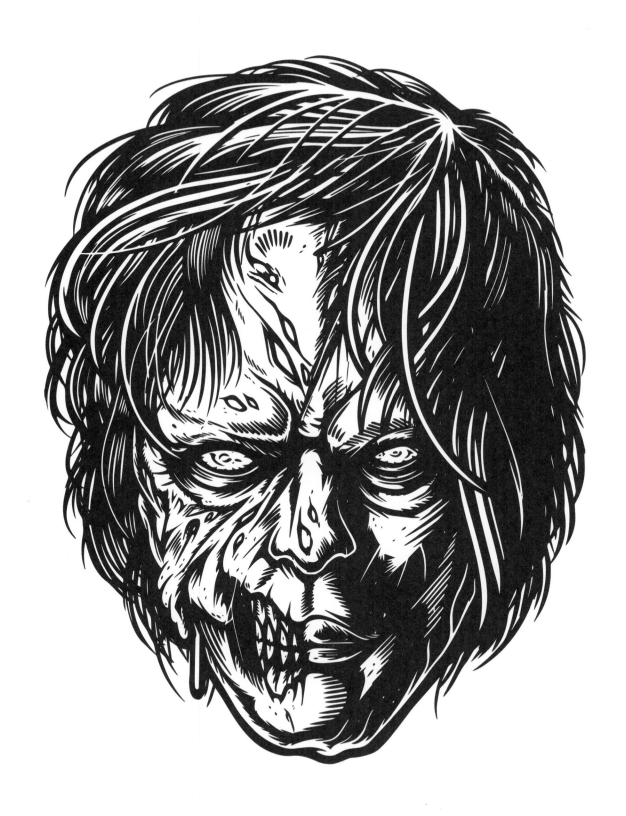

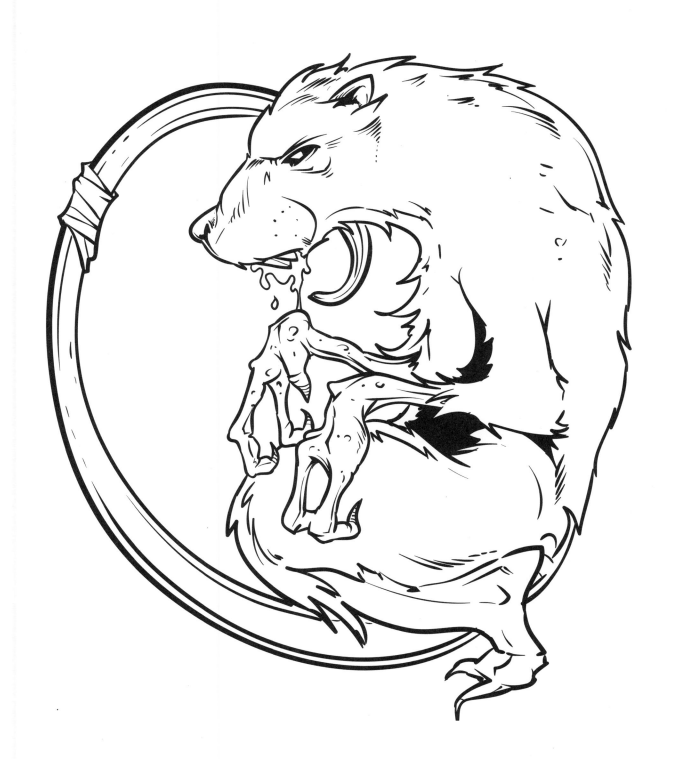

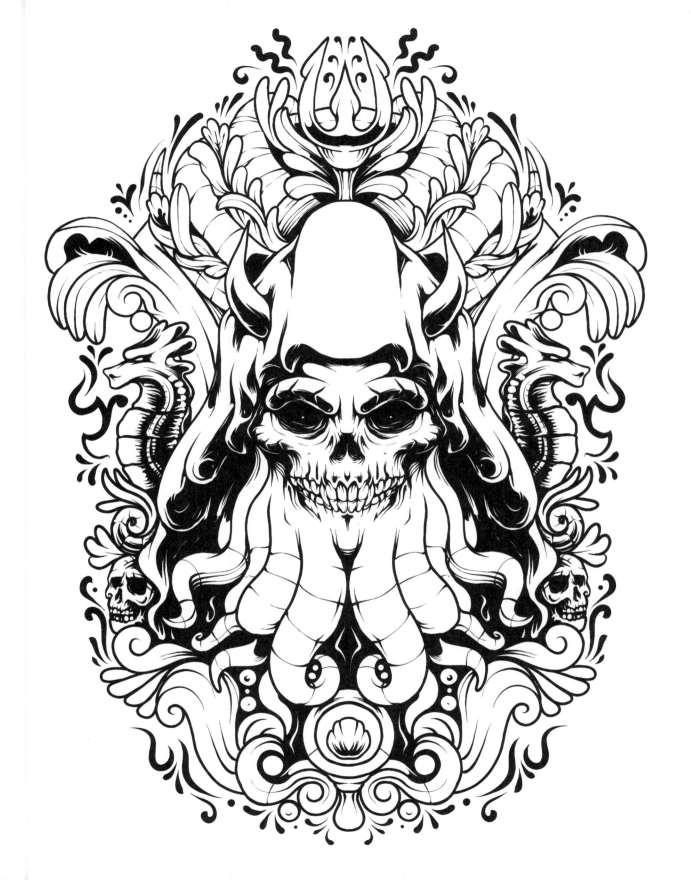

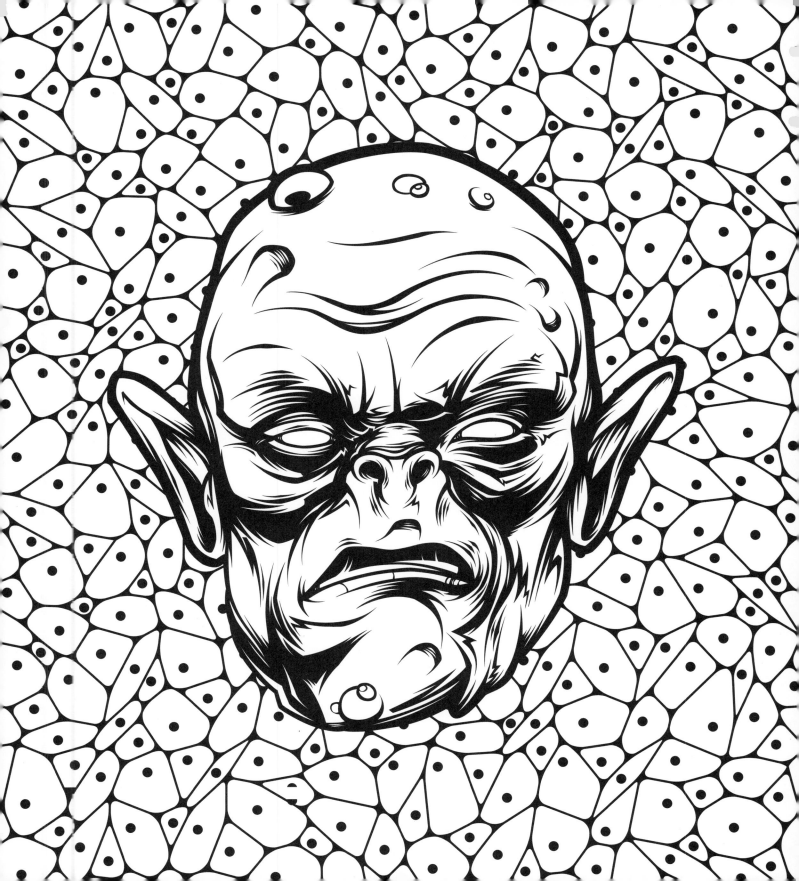

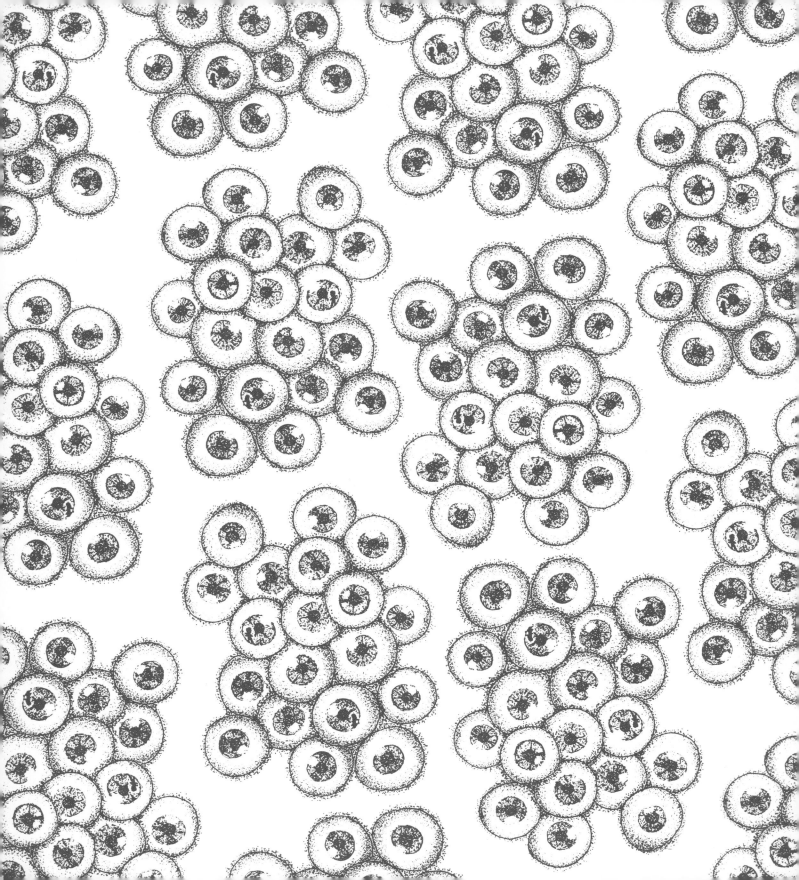

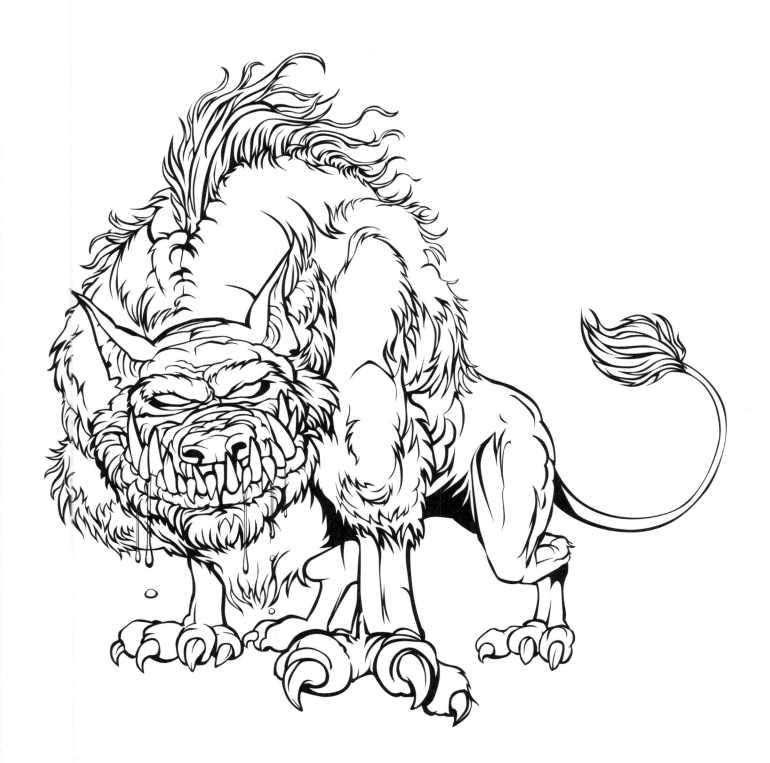

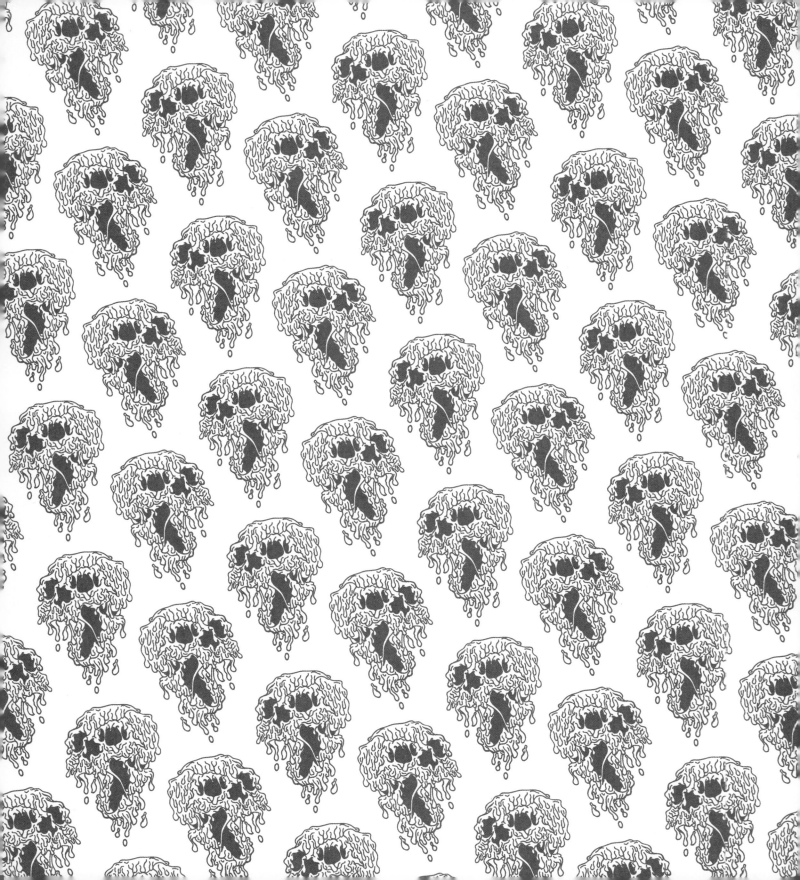

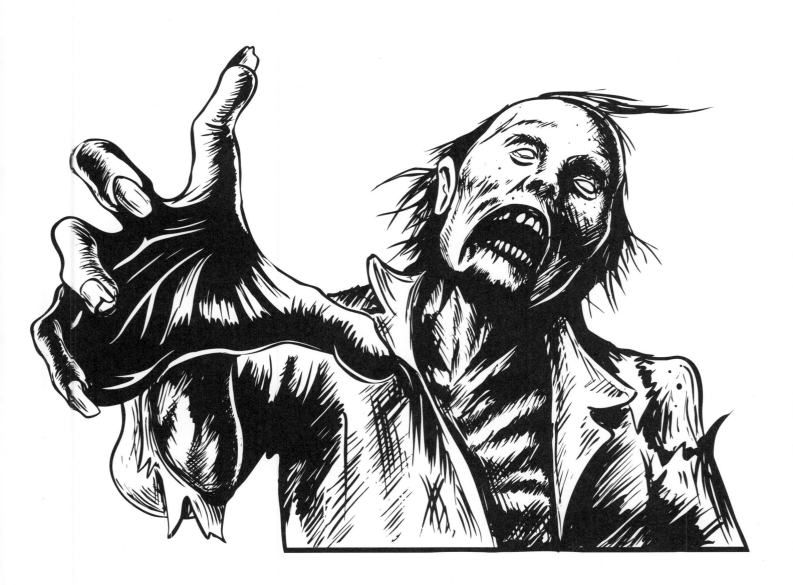

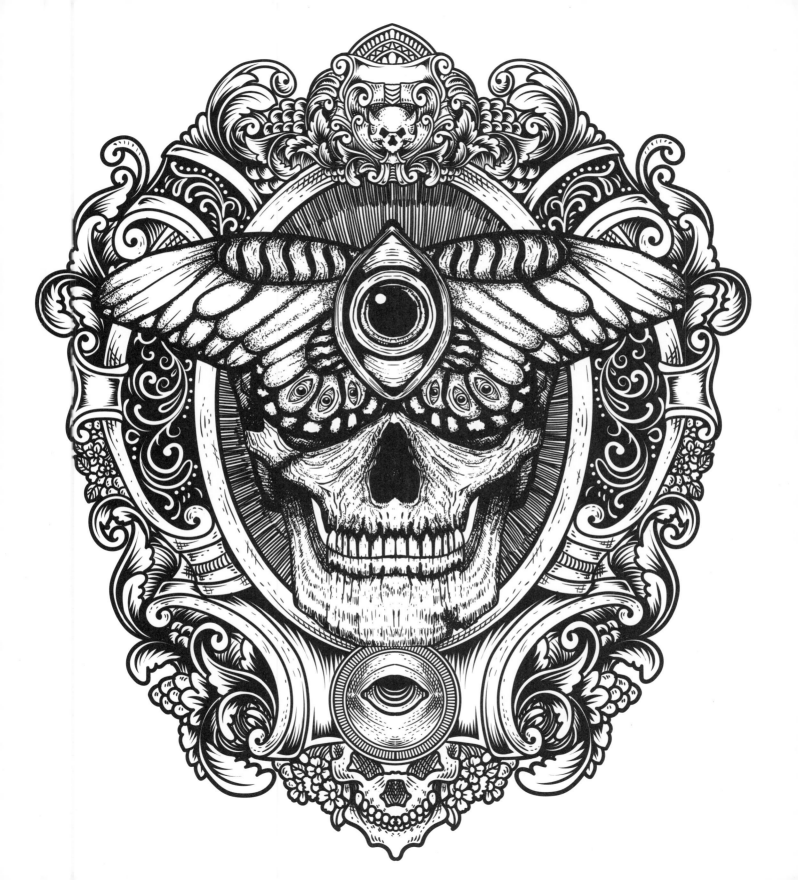

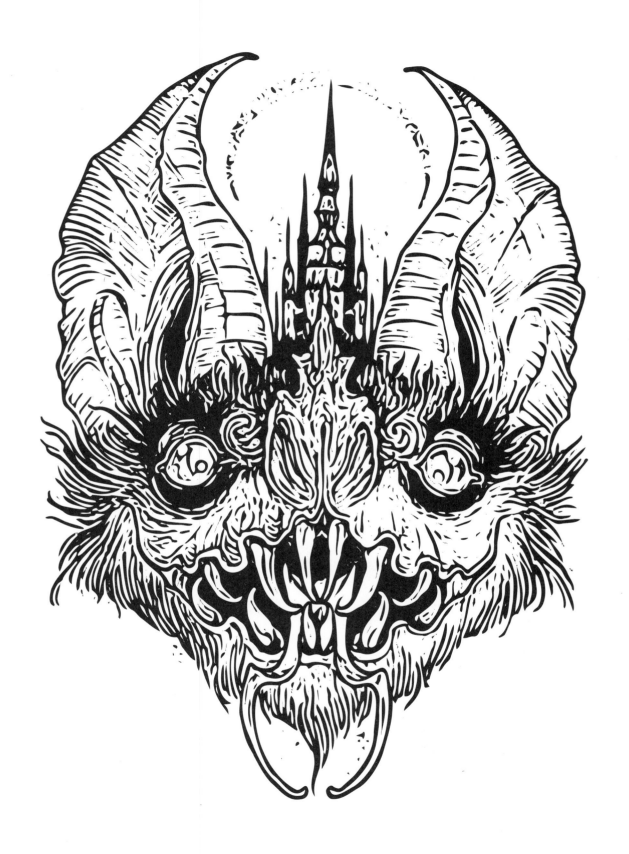

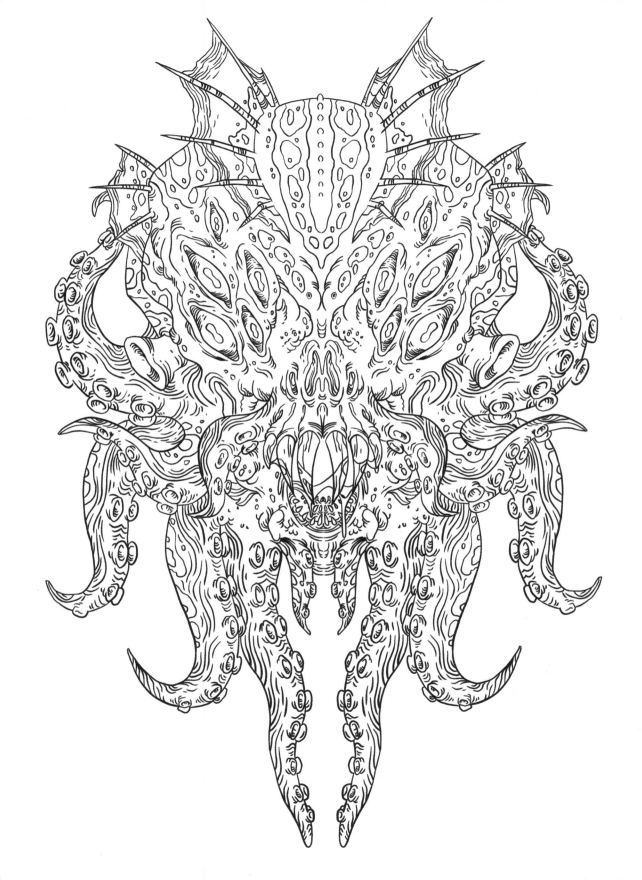

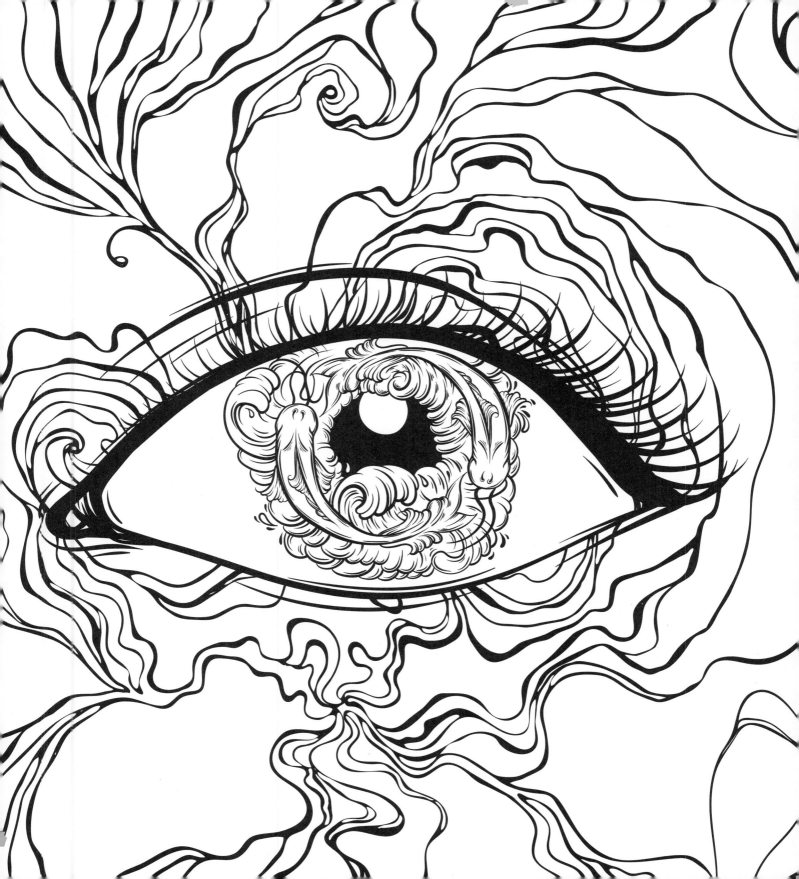

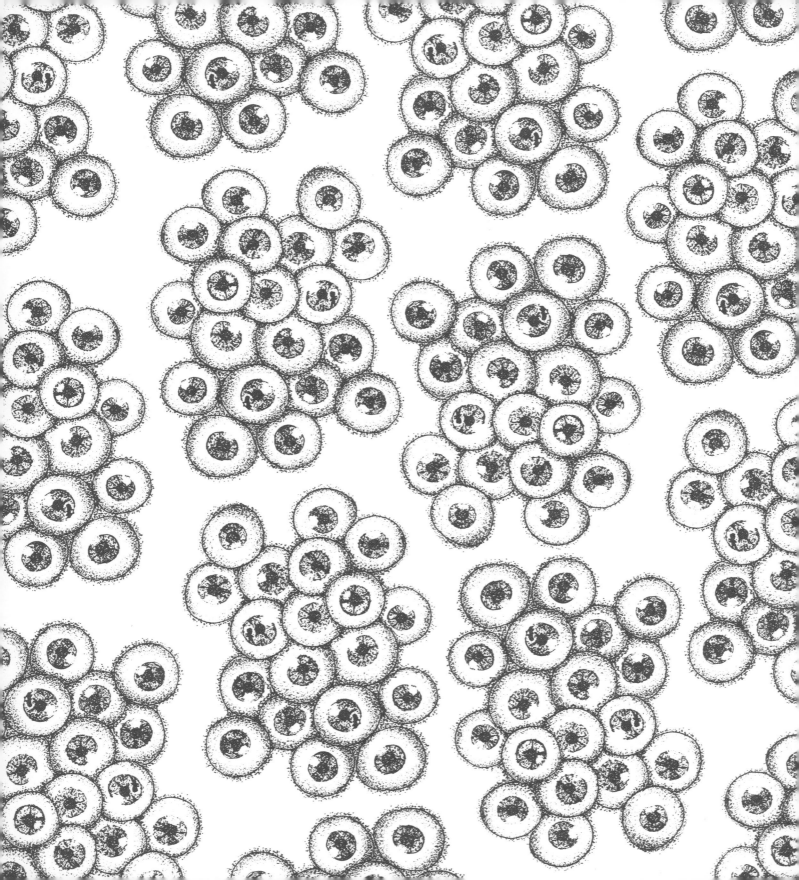

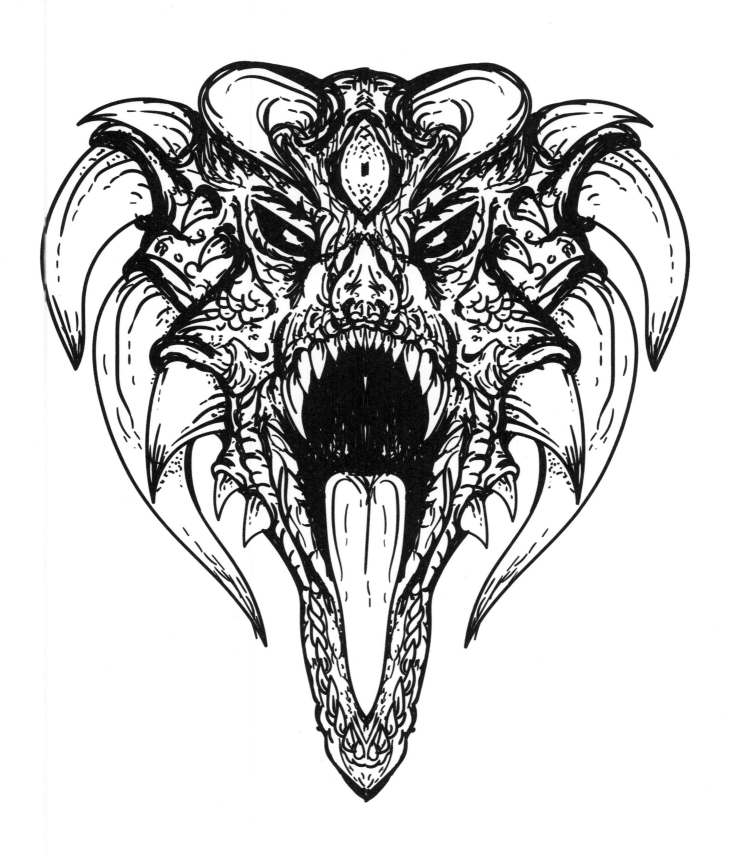

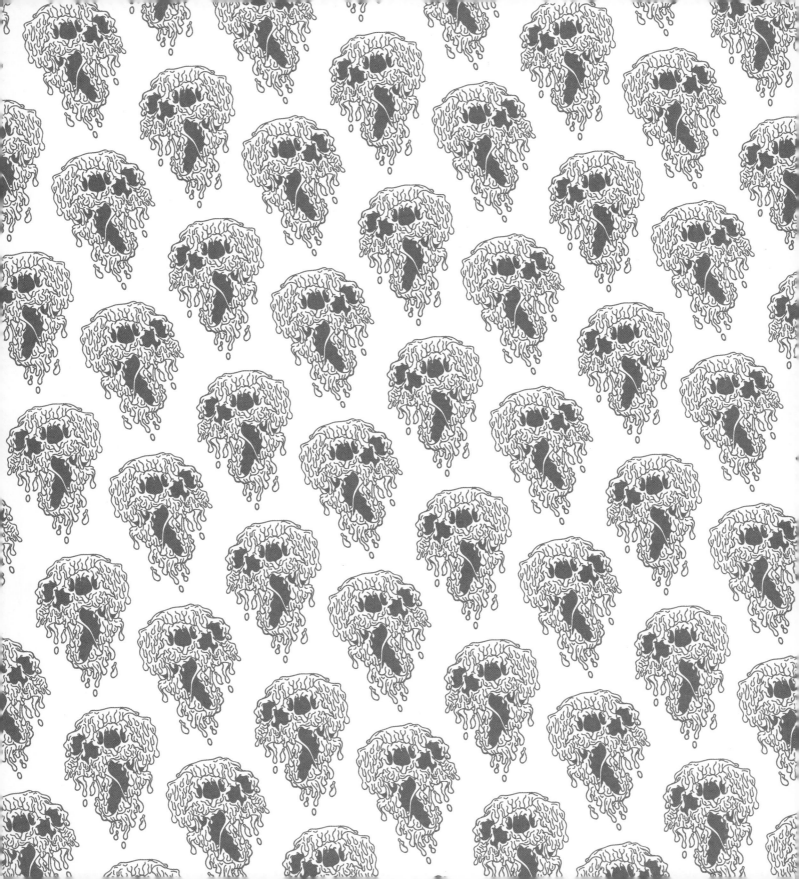

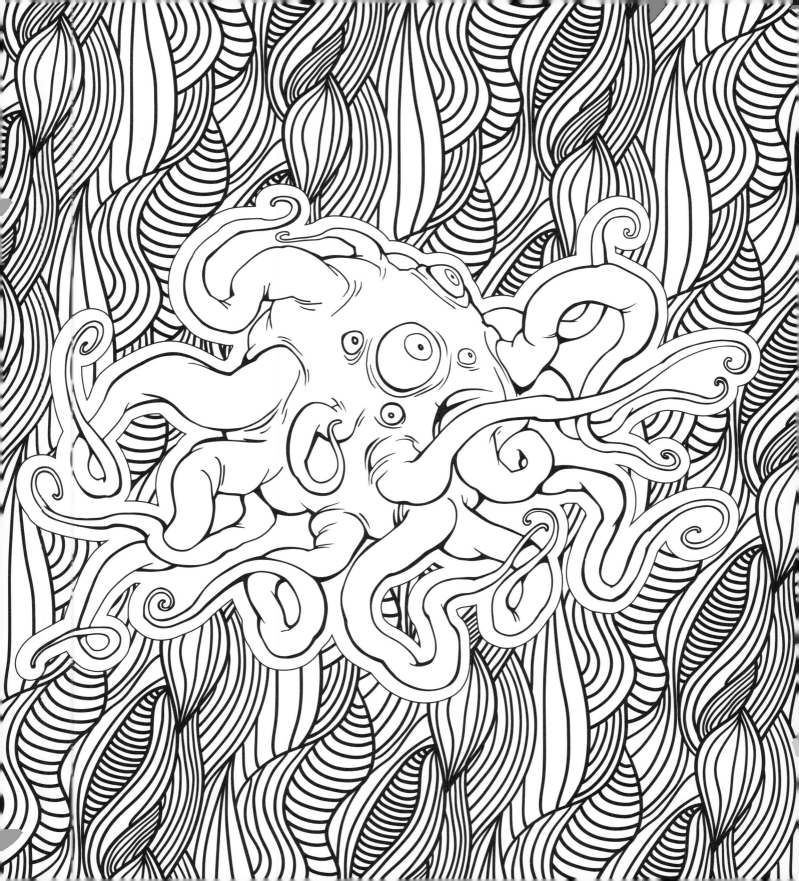

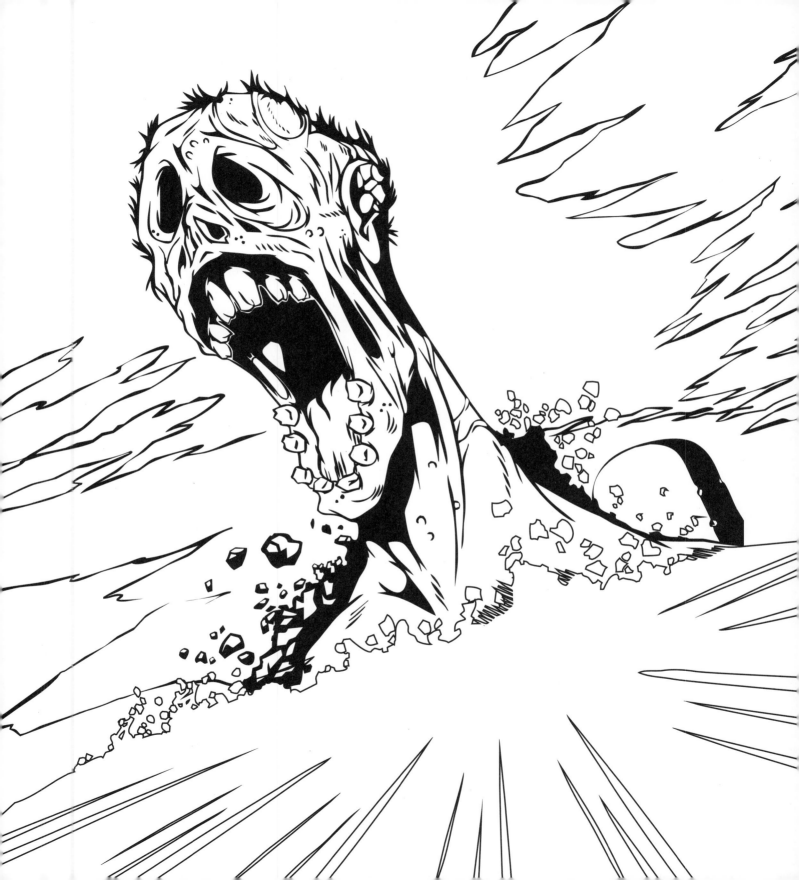

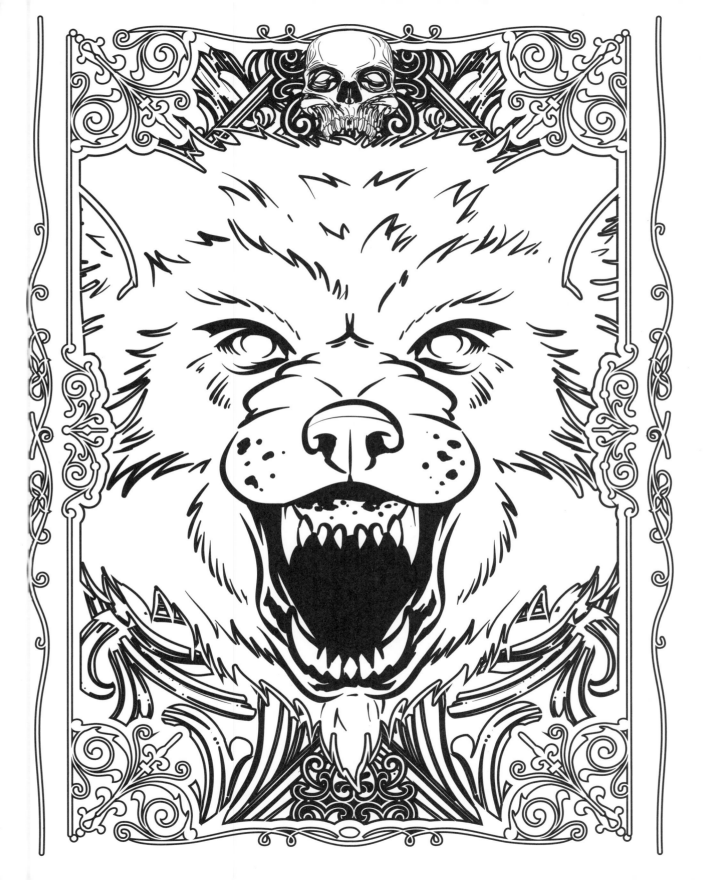

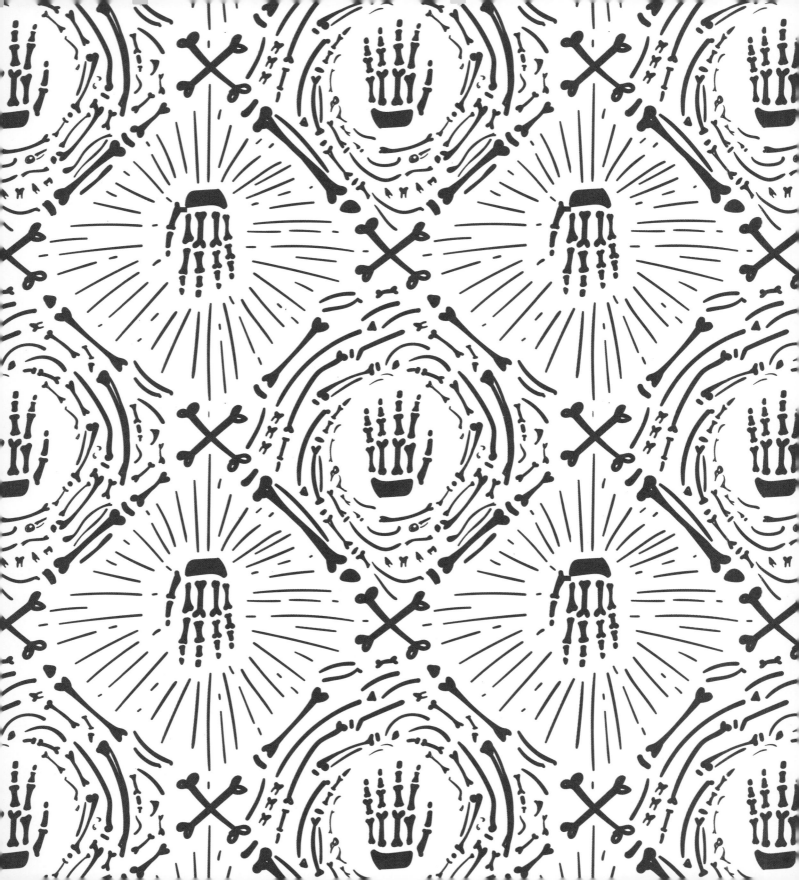

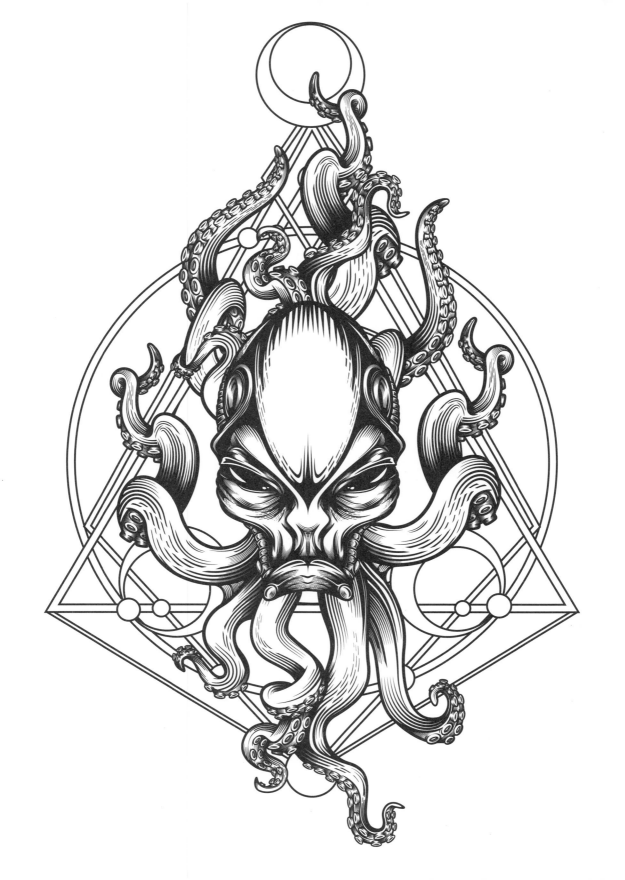

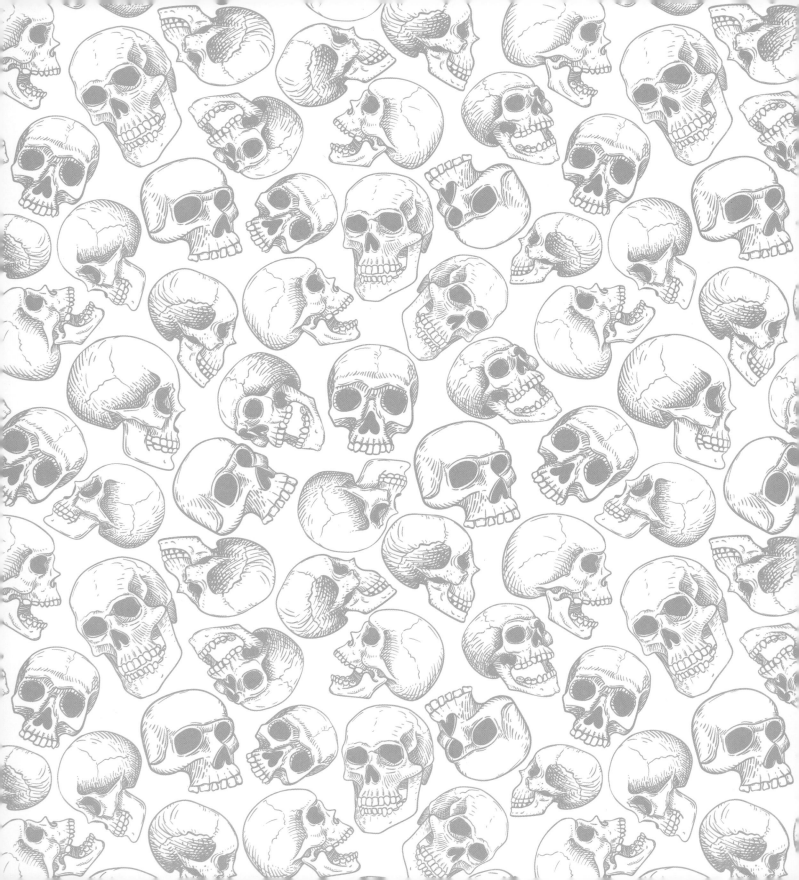

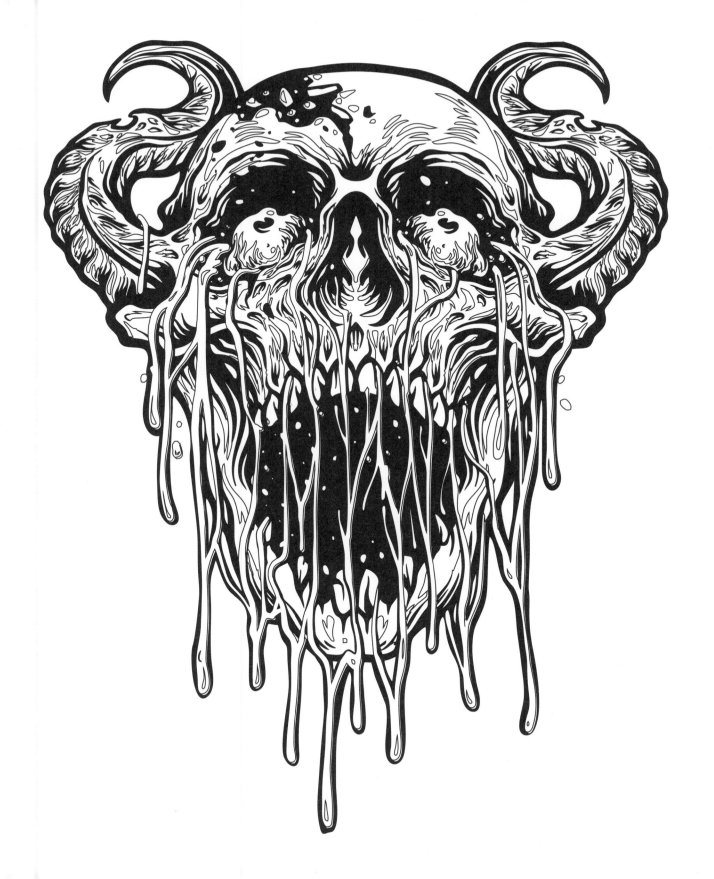

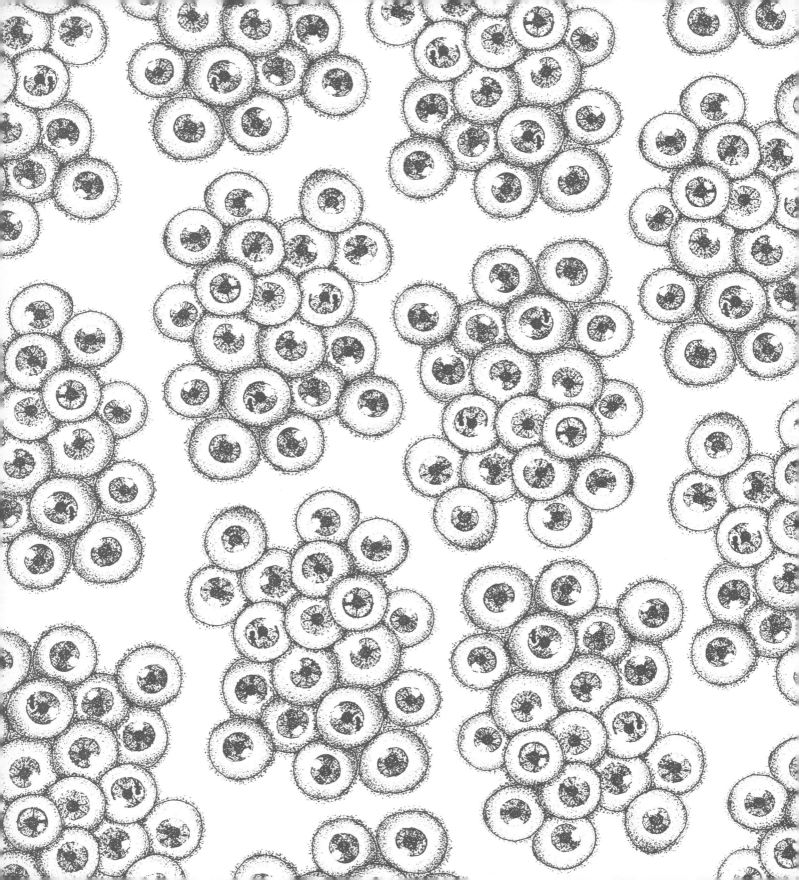

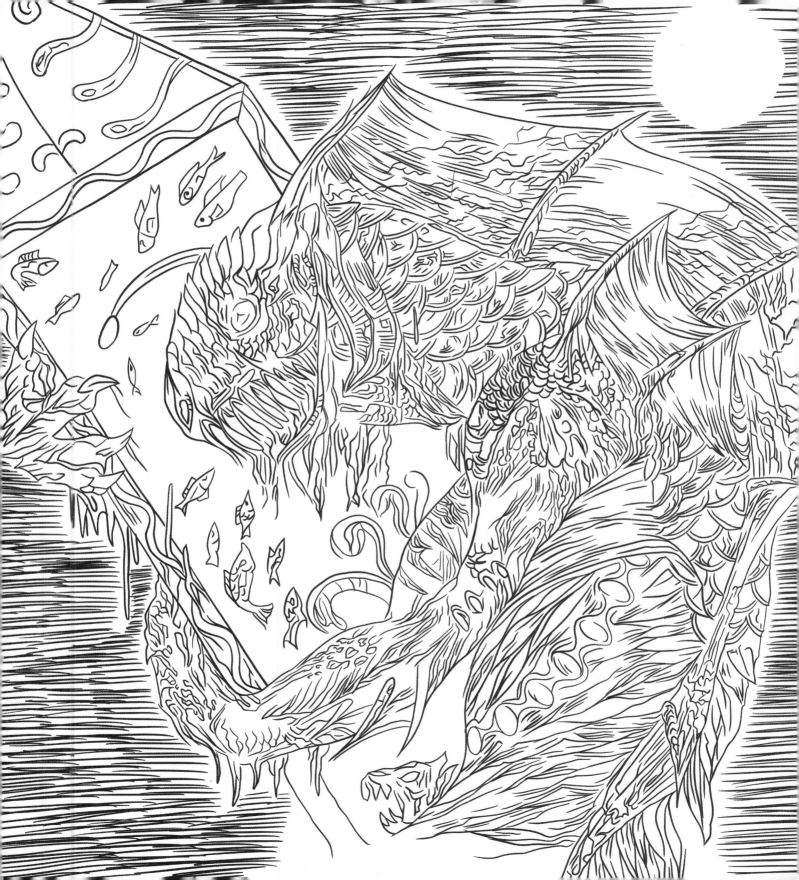

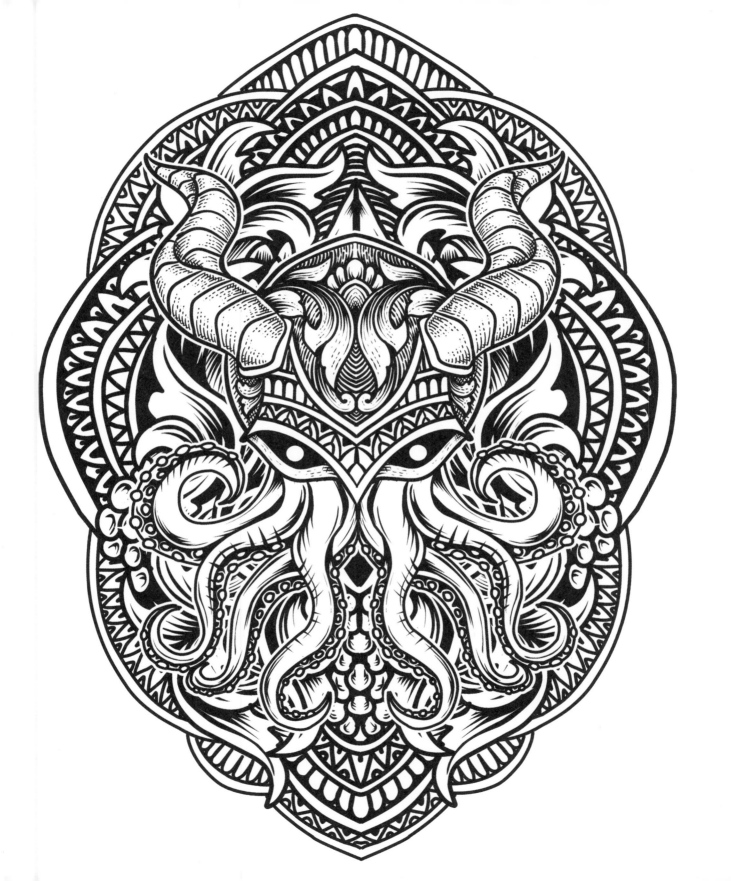

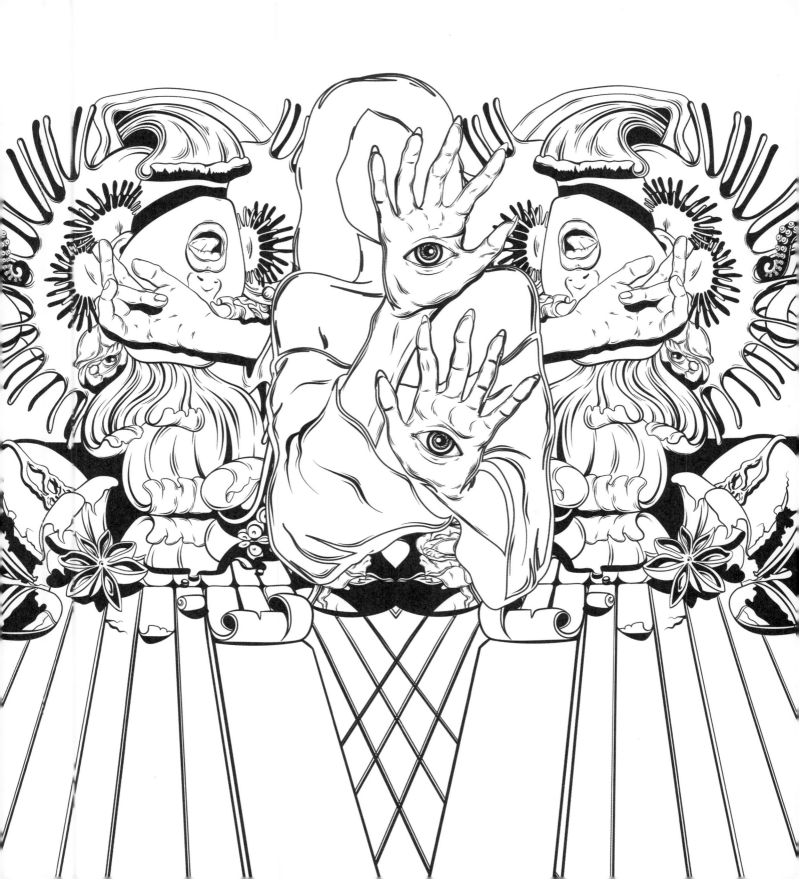

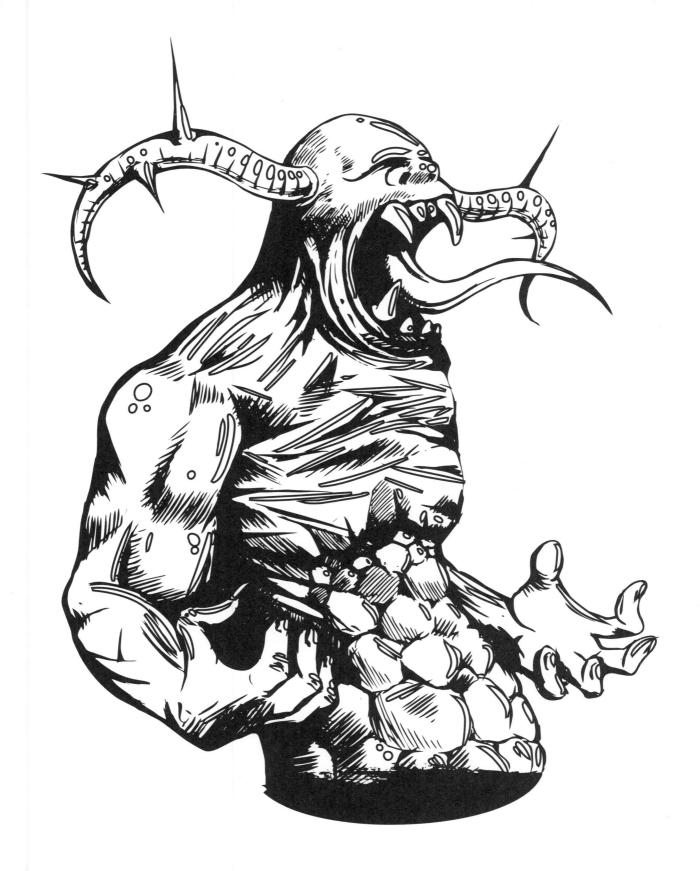

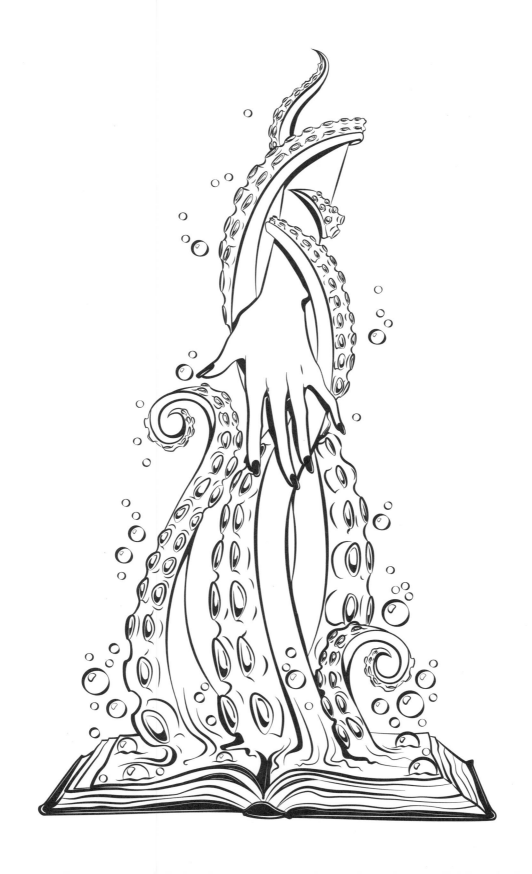

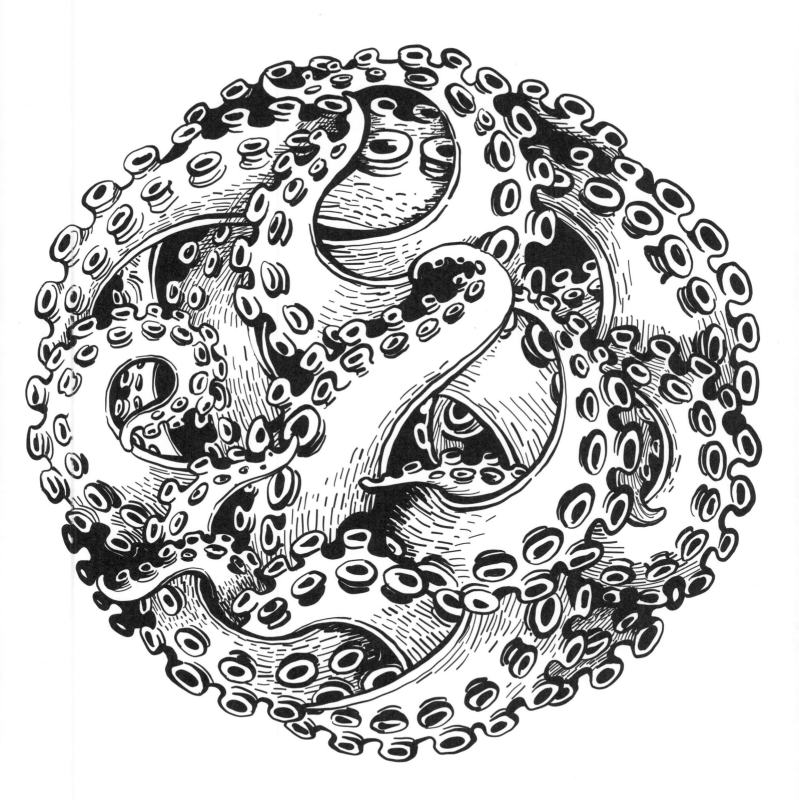

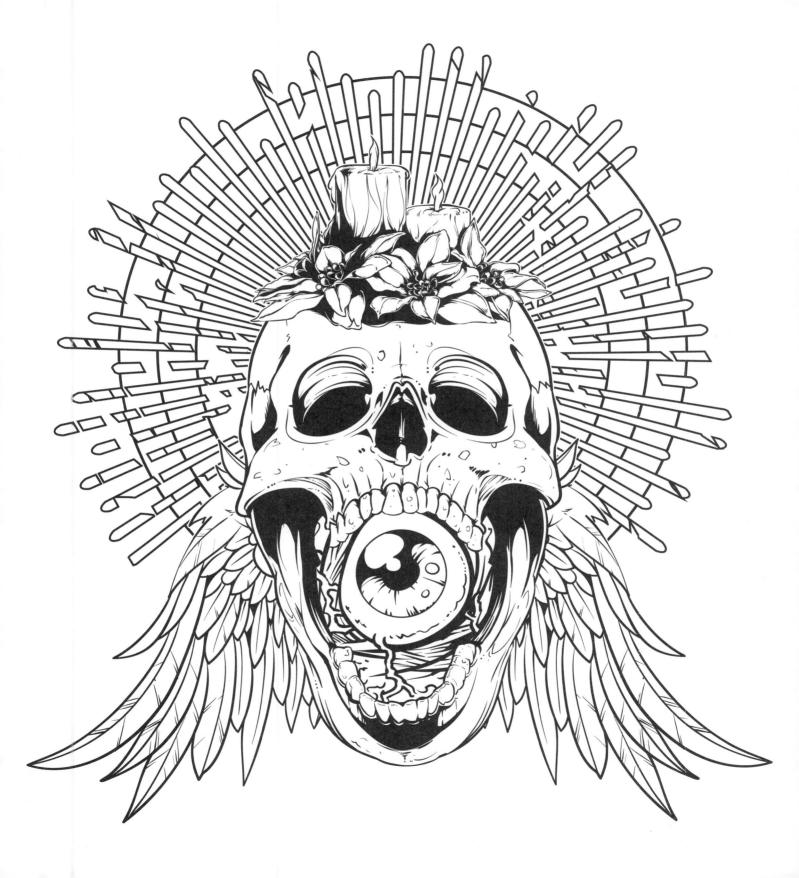

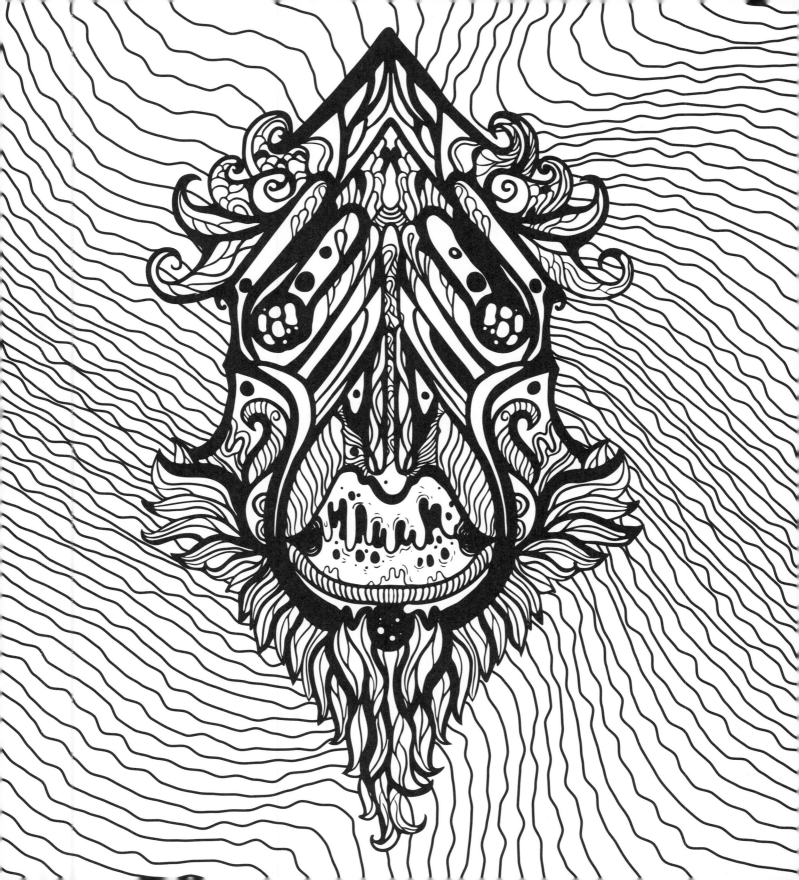

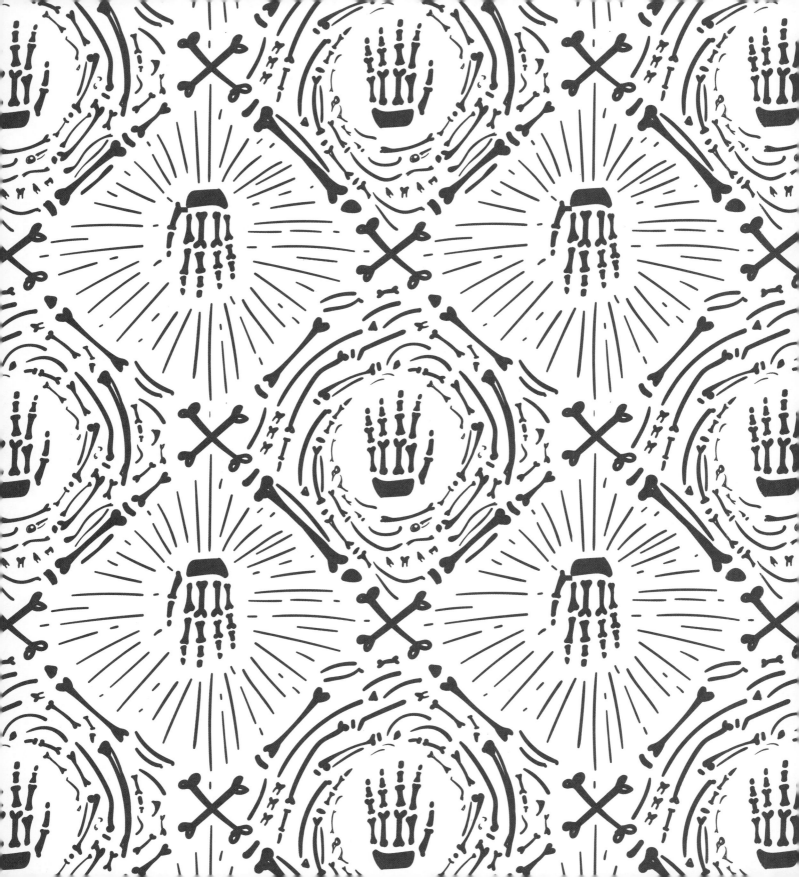

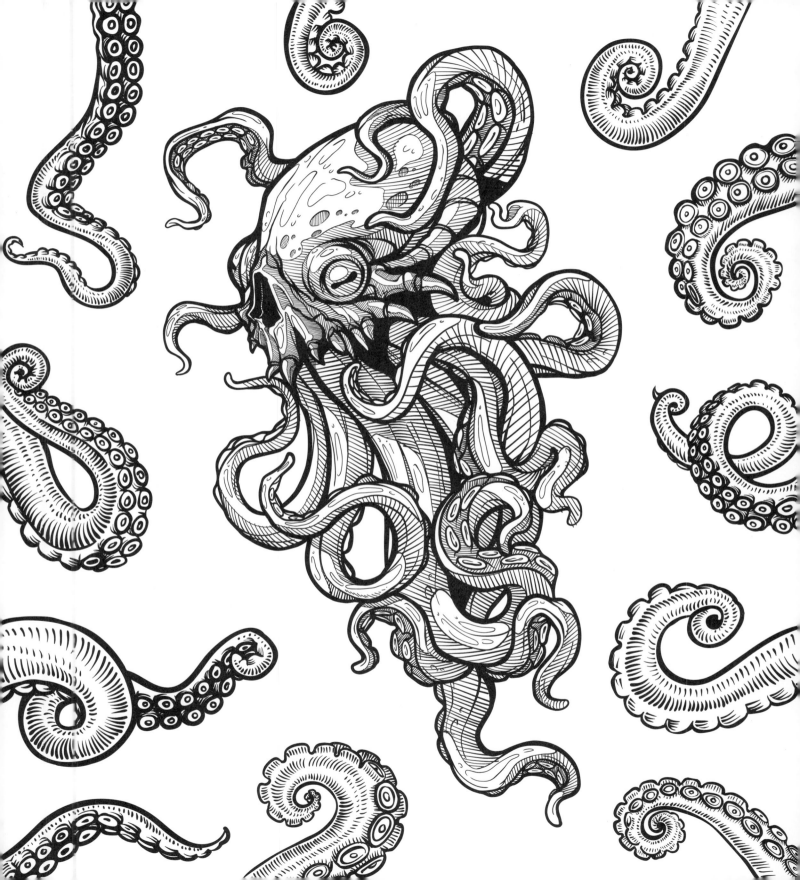

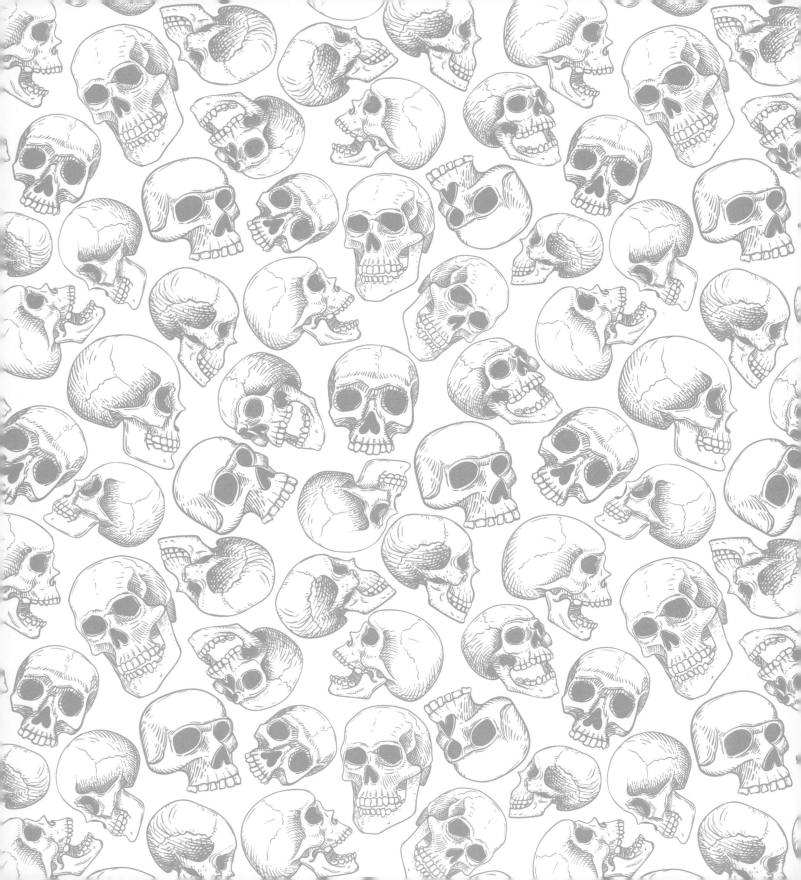

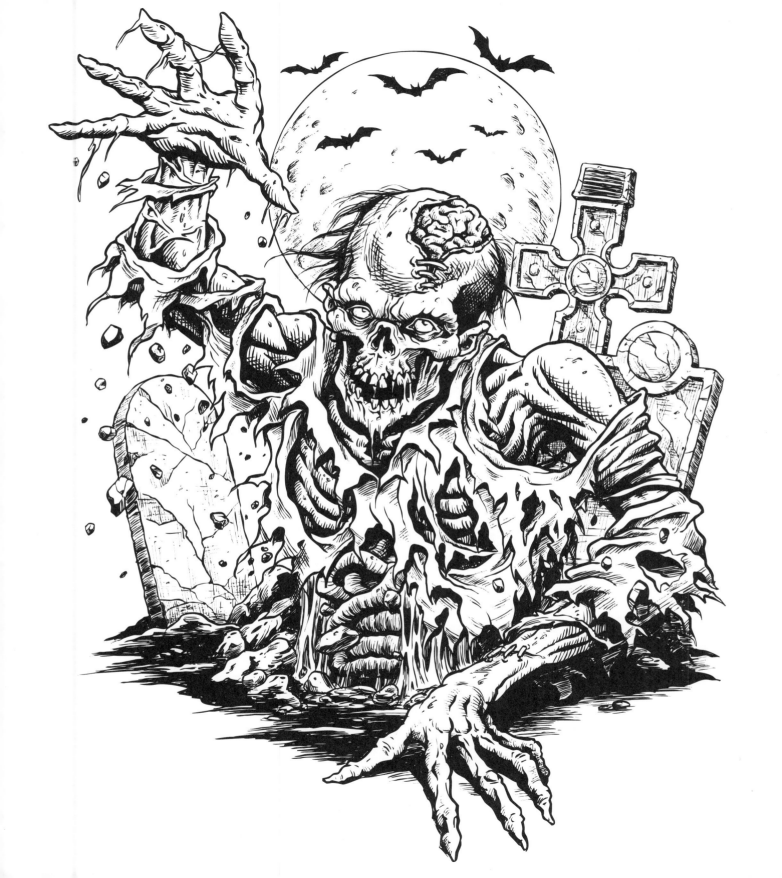

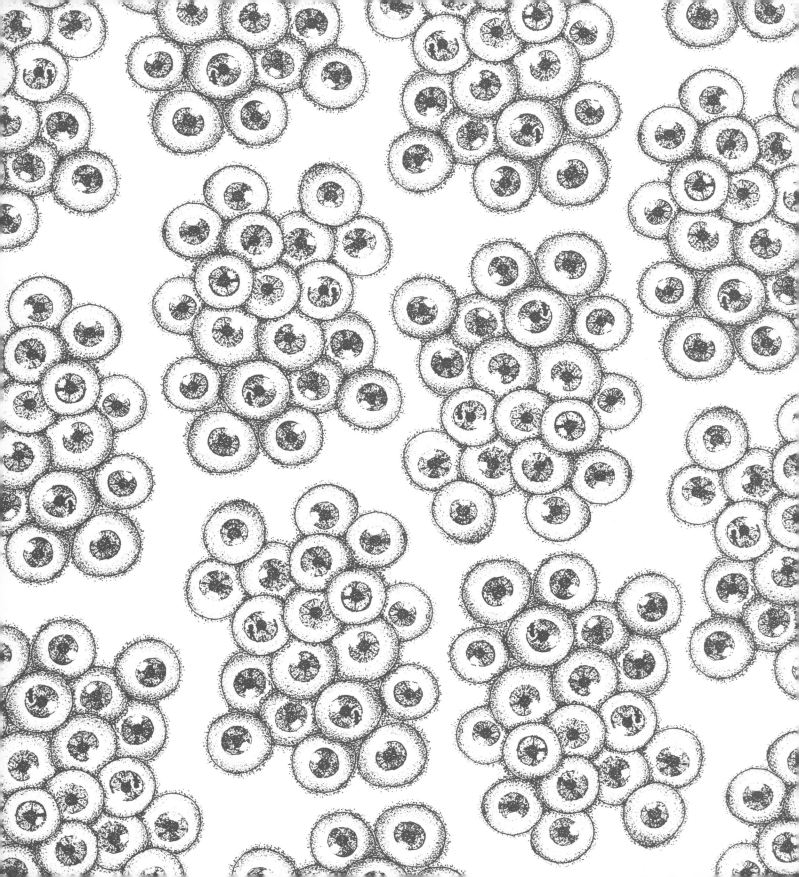

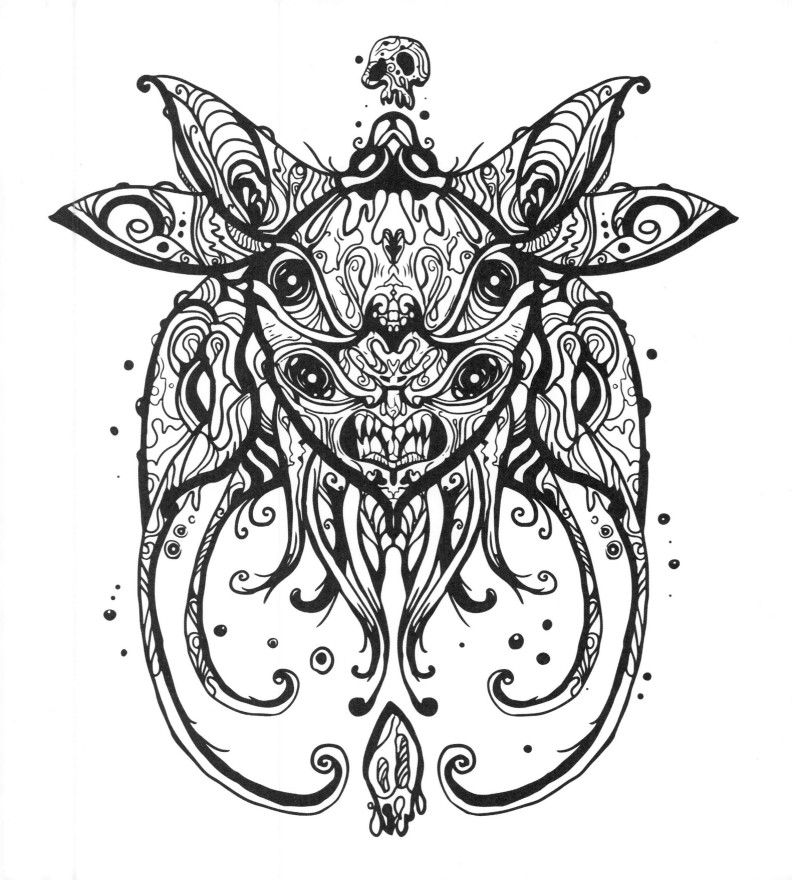

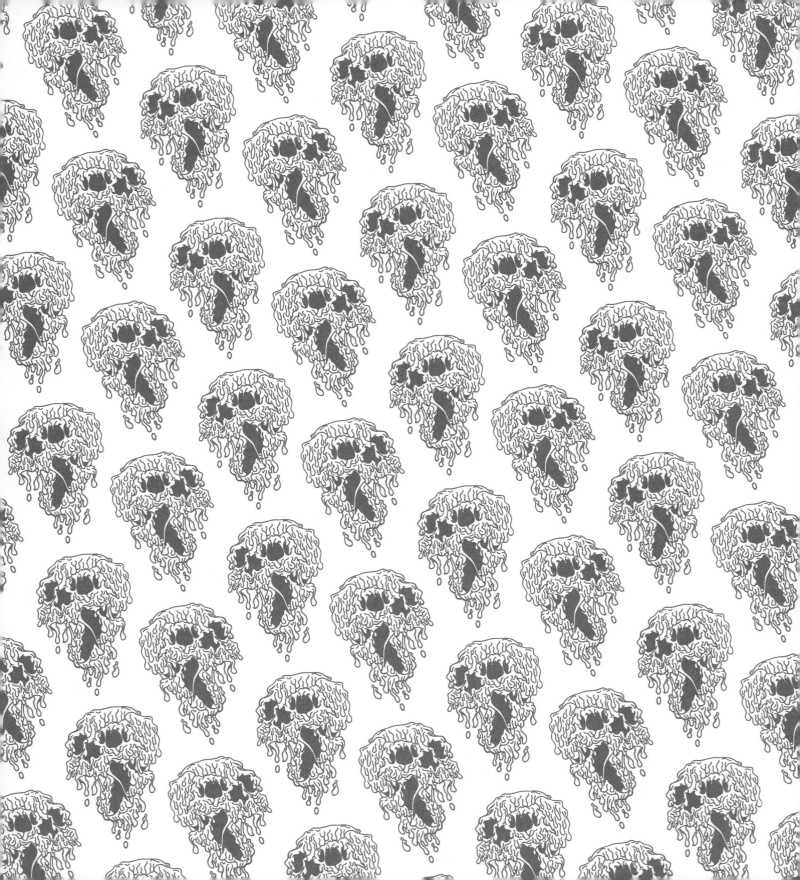

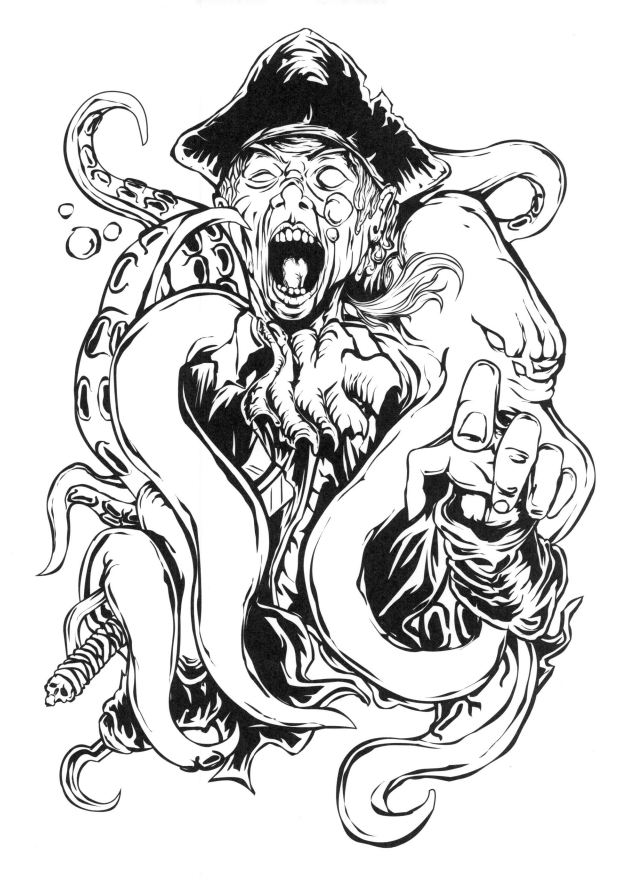

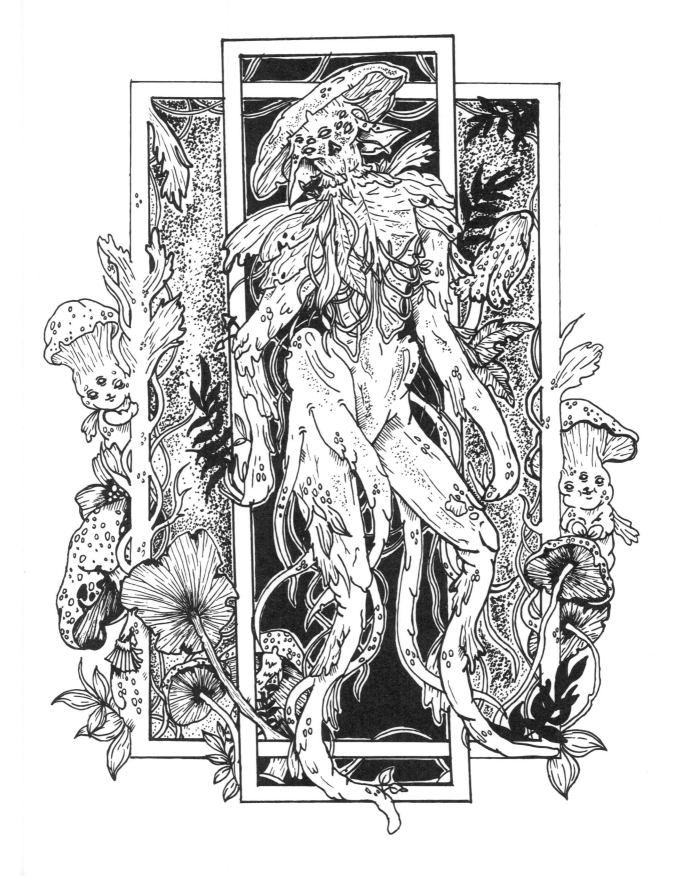

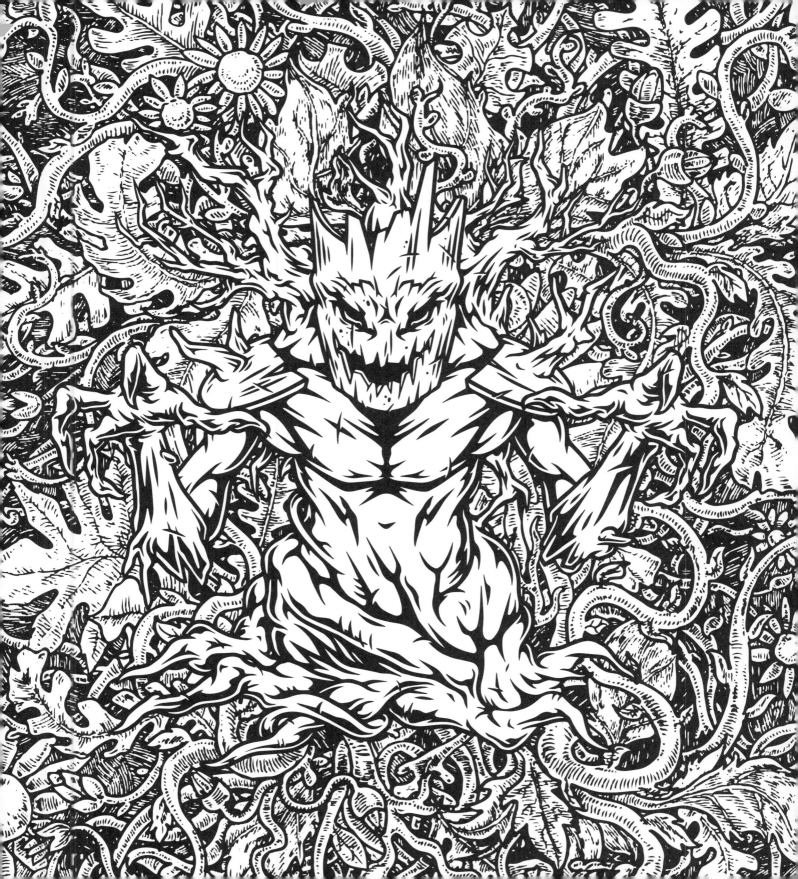

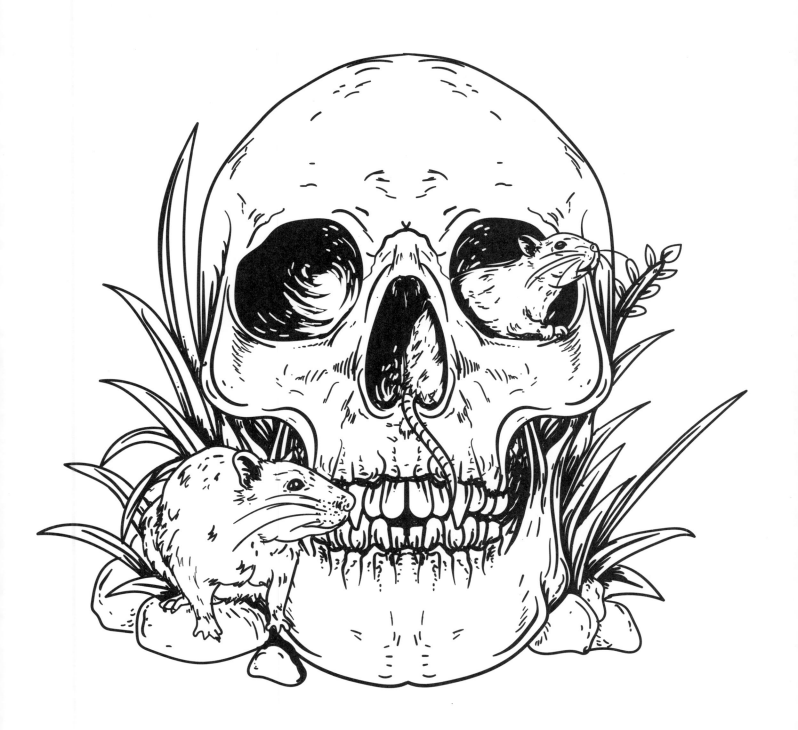

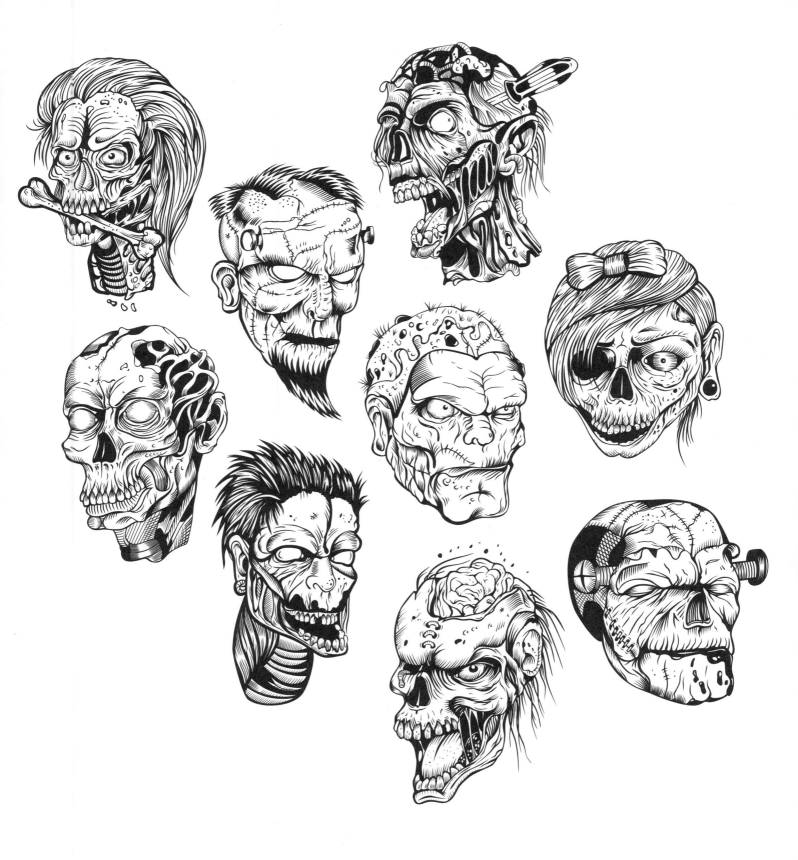

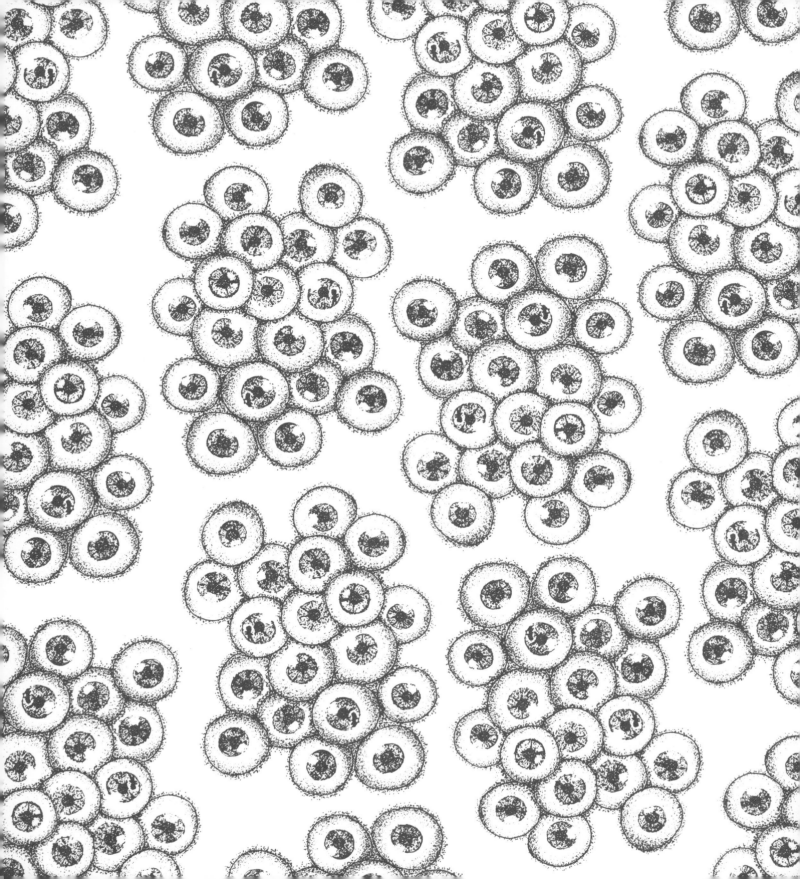

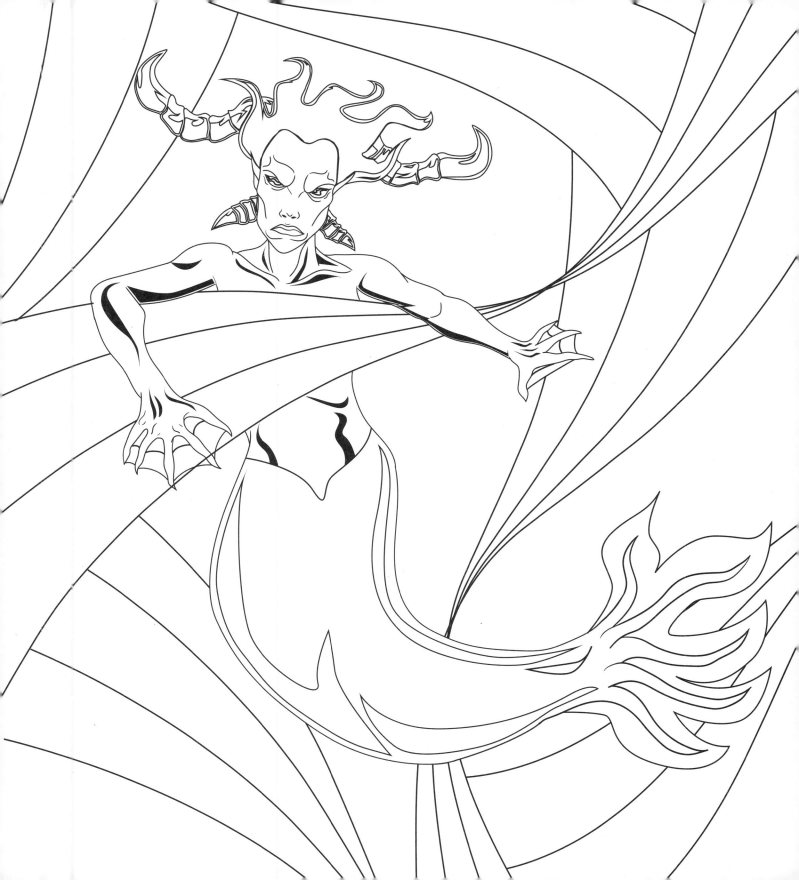

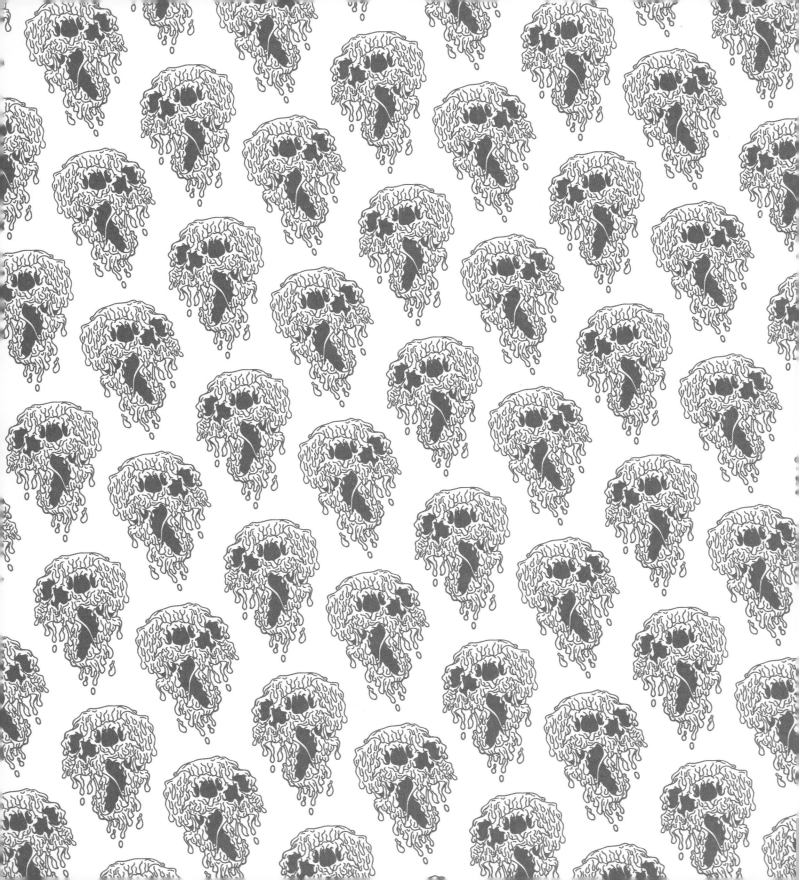

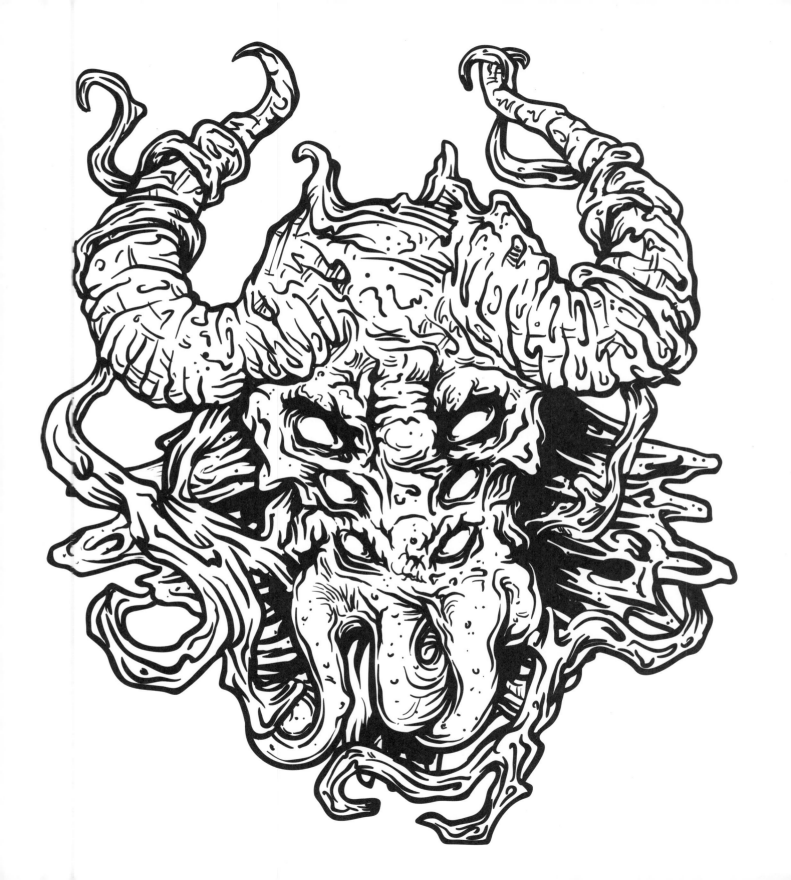

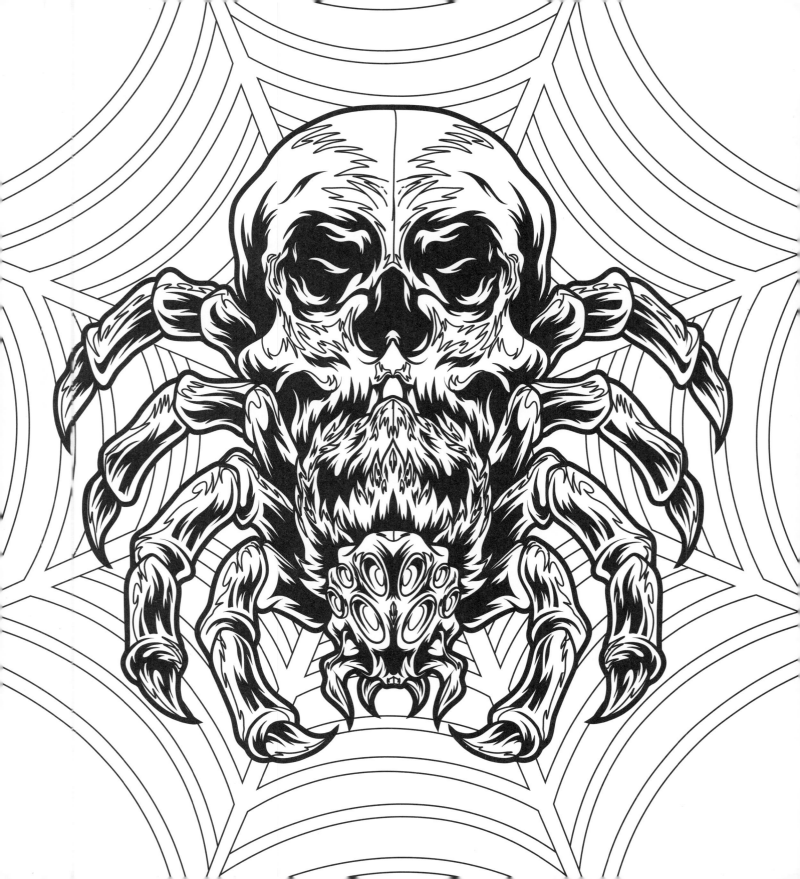

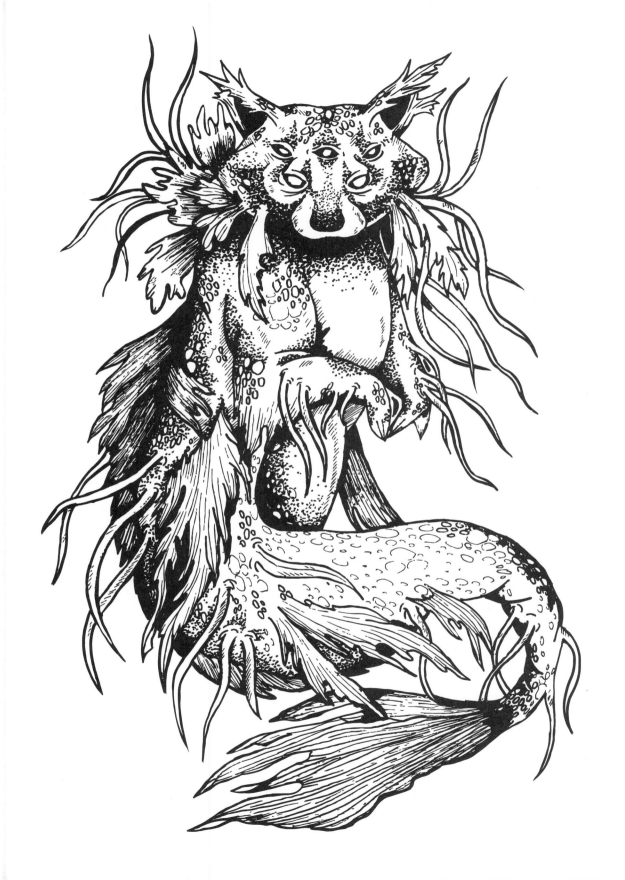

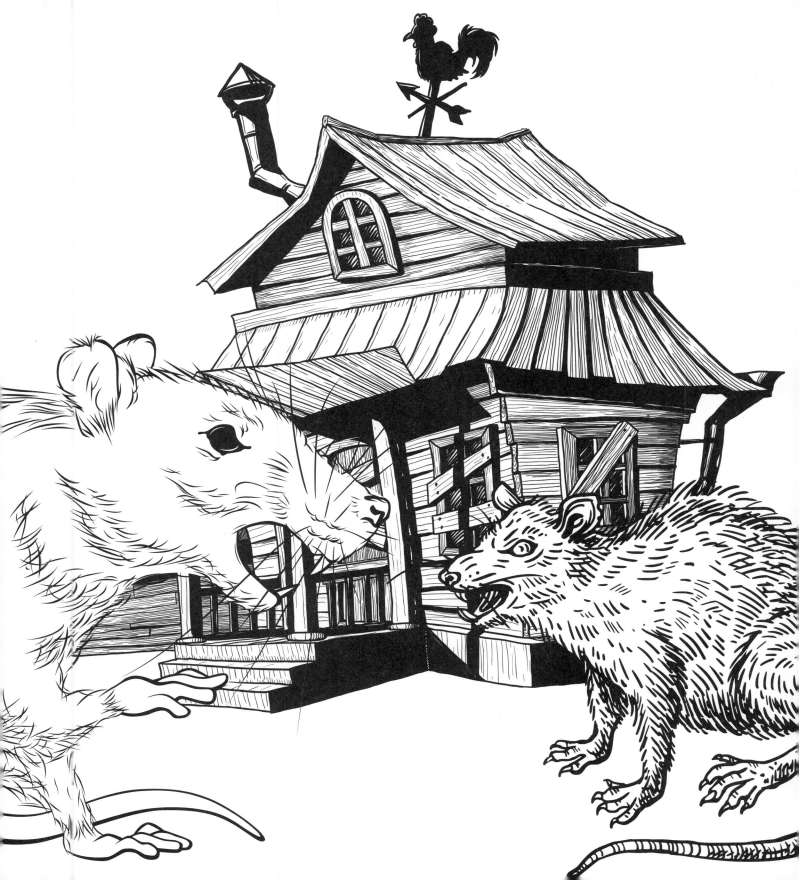

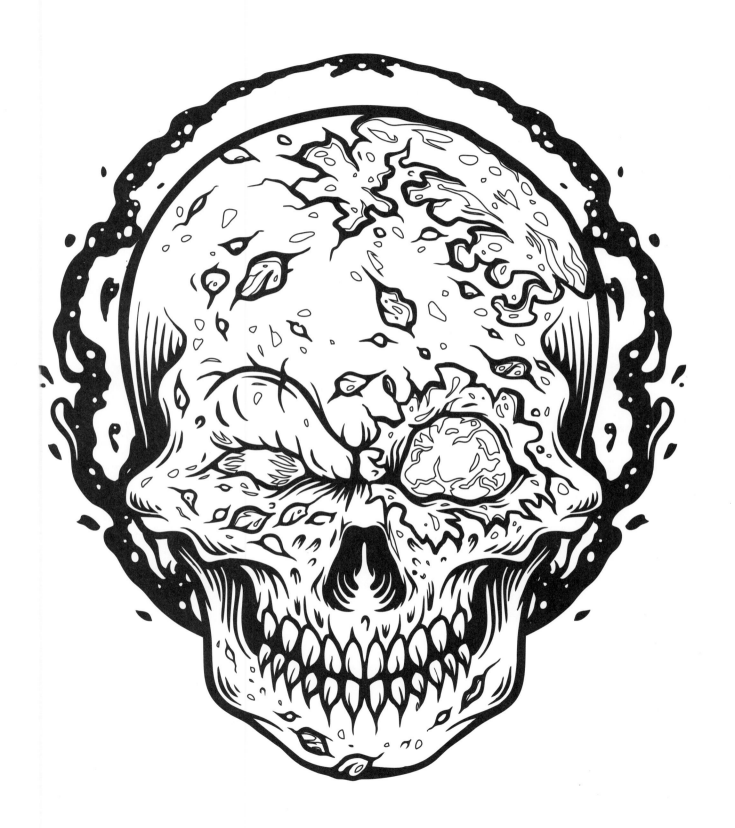

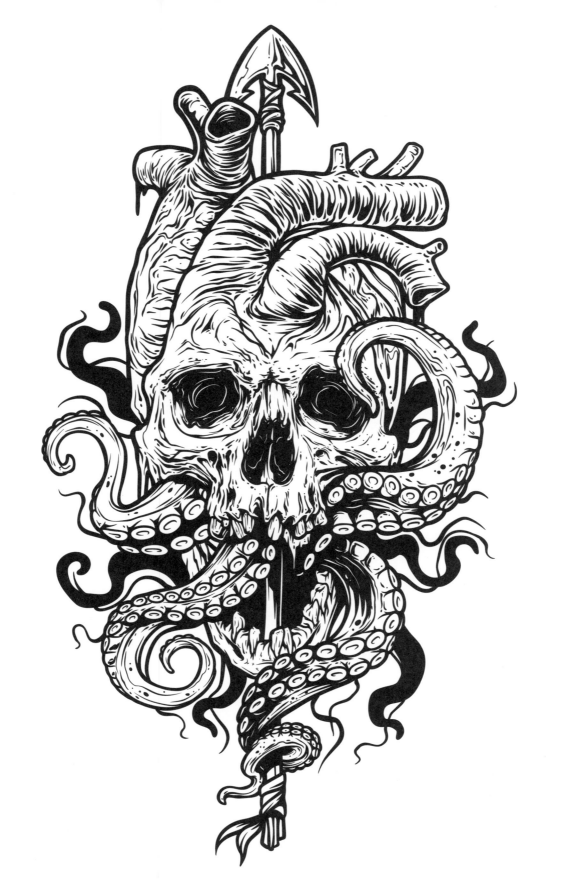

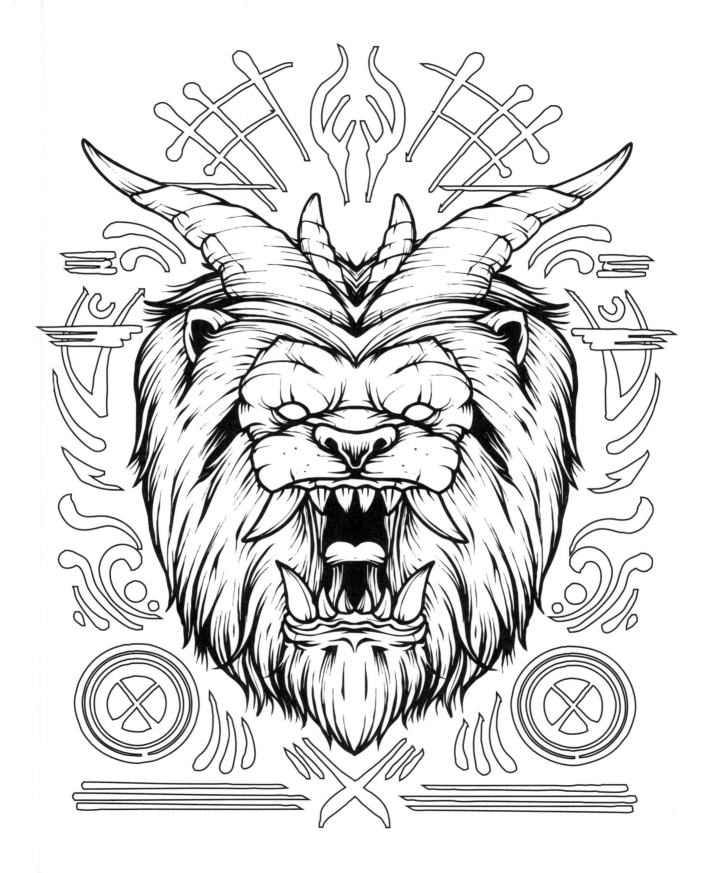

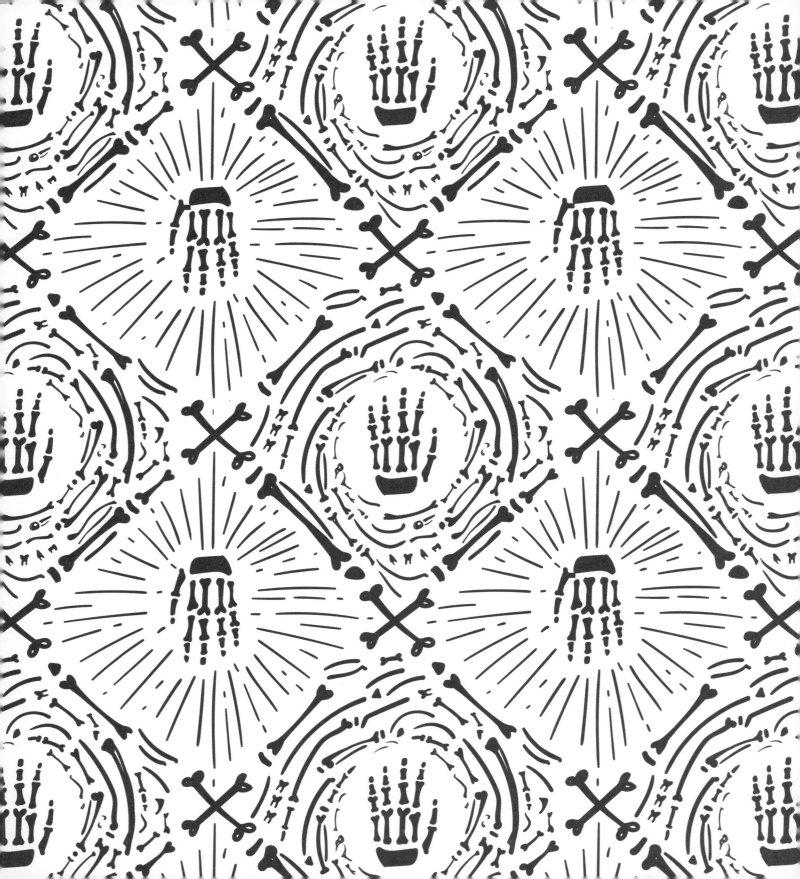

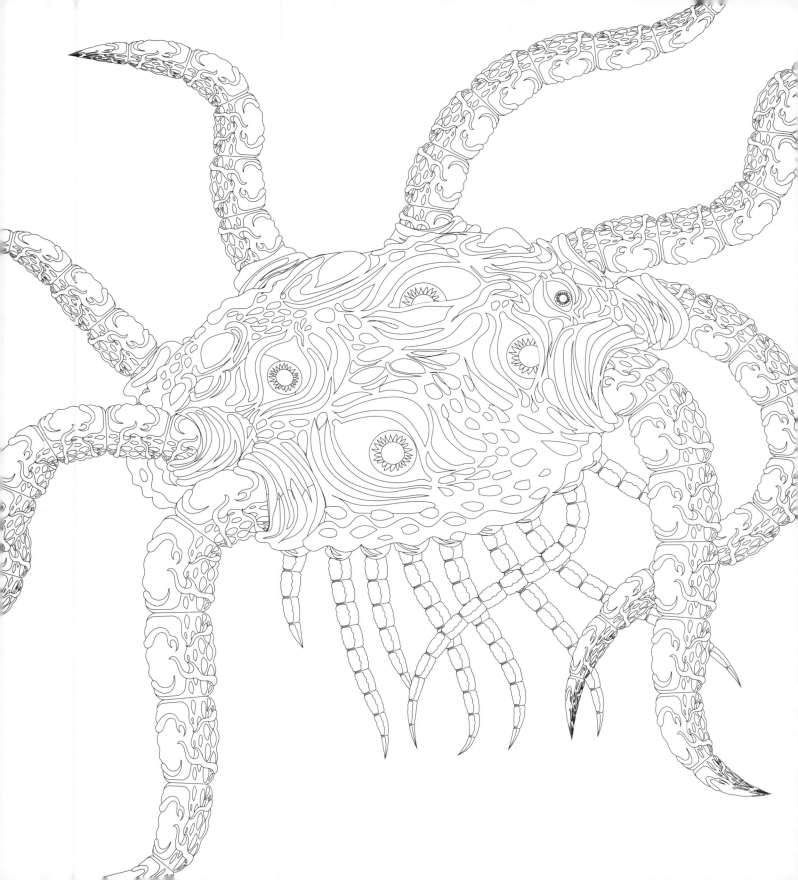

Quarto

This edition published in 2023 by Chartwell Books,
an imprint of The Quarto Group
142 West 36th Street, 4th Floor
New York, NY 10018 USA
T (212) 779-4972 F (212) 779-6058
www.Quarto.com

10 9 8 7 6 5

Chartwell titles are also available at discount for retail, wholesale, promotional,
and bulk purchase. For details, contact the Special Sales Manager by email at
specialsales@quarto.com or by mail at The Quarto Group, Attn: Special Sales
Manager, 100 Cummings Center Suite 265D, Beverly, MA 01915, USA.

ISBN: 978-0-7858-4223-1

Publisher: Wendy Friedman
Senior Managing Editor: Meredith Mennitt
Senior Design Manager: Michael Caputo
Editor: Cathy Davis
Designer: Kate Sinclair

All stock photos and design elements ©Shutterstock

Printed in China